SECRET
MAIDSTONE

Dean Hollands

AMBERLEY

Acknowledgements

I am exceedingly grateful to the staff of the Maidstone Museum and Bentlif Art Gallery, the Kent Police Museum, the Kent History and Library Centre and the Maidstone Town Hall for their assistance, professionalism and courtesy afforded to me throughout.

I am also grateful to Phil Riley and Diana Peters-Riley for their kind support in sharing their time and knowledge of photography with me.

For the use of images I am grateful to the Maidstone Museum and Bentlif Art Gallery (MMBAG), Canterbury Christ Church University and Maidstone Museum (CCCUMM), Kent Police Museum (KPM), Simon Burchell (SB), Ethan Doyle White (EDW), the Chislehurst Society, www.vconline.org.uk and www.lilianbland.ie.

Once again, I would like to offer special thanks to Cathrine Milne, Sharon Berry and Jane Sleight for their continued assistance with text, and Amberley Publishing for their continued support in publishing my books.

Finally, I would like to offer a general thanks to all those who made my time growing up in Maidstone such a wonderful experience and who contributed to the creation of such fond memories – you know who you are!

First published 2019

Amberley Publishing
The Hill, Stroud
Gloucestershire, GL5 4EP

www.amberley-books.com

ISBN 978 1 4456 8864 0 (print)
ISBN 978 1 4456 8865 7 (ebook)

British Library Cataloguing in Publication Data.
A catalogue record for this book is available from the British Library.

Origination by Amberley Publishing.
Printed in Great Britain.

Contents

Foreword 4

Introduction 5

1. Megaliths, Monuments and Memorials 7

2. Medieval Maidstone, Murder, Meetings and Markets 18

3. Riots, Rebellions and Revolts 32

4. Sons, Daughters and Colourful Characters 40

5. Defence, Dedication and Devotion 53

6. Gallows, Gaols, Punishment and Policing 63

7. Bears, Bombs and Bones 74

8. Mysteries, Manifestations and Other Curiosities 87

About the Author 96

Foreword

As a long-standing councillor for the borough of Maidstone and now upholding the honorary tradition of being the mayor of the county town, I am fascinated by the history of our local community. In this position I am lucky to have strong connections with the Town Hall, which Dean visited in the course of his research for his new book, *Secret Maidstone*.

As a former Magistrates' Courts and with its own gaol cell (in use before the facility in Boxley Road was built), I'm sure that this Georgian building has secrets of its own. I look forward to discovering more about this historic site and Maidstone as a whole through Dean's expertise.

It is important that we all take the time to find out more about the areas in which we live in order to fully appreciate the buildings and history that surrounds us. Maidstone is a vibrant town with many interesting and significant events within its past, and by supporting this book I hope to encourage more of us to find out something new about where we live and work.

Wishing Dean Hollands thanks and every success with the publication of *Secret Maidstone* – there is undoubtedly much to uncover.

Councillor David Naghi
Mayor of Maidstone, May 2018 – May 2019

Introduction

Above all, watch with glittering eyes the whole world around you because the greatest secrets are always hidden in the most unlikely places.

Roald Dahl

This book has been written for the residents of Maidstone – both long-standing and recently arrived – and for those intending to visit this most curious and interesting of places.

The subject matter has been carefully selected and is intended to serve several functions. Firstly, in this age of social media, information previously not readily available is now so generously shared among like-minded groups. For this section of society, who have a keen and enthusiastic interest in the people, places and events that have shaped the borough, the title *Secret Maidstone* may seem rather misleading, as few things about Maidstone and its past are truly secret.

But even among those more enlightened residents, it is clear from researching this book that with the passage of time some things fade from memory and others are forgotten completely or change in their telling from one generation to another. That said, as will be discovered within the pages of this book, there are many interesting facts about the borough's history and its heritage that are still waiting to be discovered. Some of which are hidden and hard to find, while others often exist in plain sight, their significance overlooked.

Secondly, for many others most of what rests between the covers of this book will be a revelation. As for those who are just visiting, it offers a wealth of information about the history and heritage to be found within the borough.

Whichever group the reader belongs to, within this book there will be things that all but the most knowledgeable person won't know. These are the secrets that await your discovery. It is my hope that this book will inspire others to learn more about the borough's history and, in so doing, take time to not only visit the locations and sites mentioned herein but to explore further and find new locations and interesting facts of their own.

Each chapter comments upon a subject intrinsically linked to Maidstone's rich and diverse history, and in so doing presents the reader with what for many will be lesser-known stories and facts about that subject.

Starting with Megaliths, Monuments and Memorials, the first chapter considers those often forgotten, overlooked or seldom visited locations, revealing their unique and fascinating stories. Medieval Maidstone, Murder, Meetings and Markets tells the tale of the town's evolution and its experience of river monsters, Vikings, the Black Death, unholy hoodwinking and the many marvellous medieval buildings that remain. Riots, Rebellions and Revolts reveals the influential role played by inhabitants in repeatedly challenging authority, attempting to overthrow royalty and to secure freedoms. In Sons, Daughters and Other Colourful Characters, the fourth chapter reveals an unusual collection of talented, famous and infamous residents.

Within Defence, Dedication and Devotion, Maidstone's castles and churches reveal a treasure trove of interesting facts concealed within these often-overlooked historic gems. In Gallows, Gaols, Punishment and Policing the often grim methods employed to deal with criminality and the evolution of the town's police force are presented. Bears, Bombs and Bones brings together an odd assortment of fascinating anecdotes and facts now generally forgotten. Concluding with Mysteries, Manifestations and Other Curiosities the final chapter ponders some of the borough's supernatural, paranormal and anomalous experiences.

Throughout each chapter are some special facts under the 'Did You Know?' heading. These include interesting tidbits such as did you know that the bell in the Town Hall clock tower (which once adorned a beautiful water conduit in the town) would ring out to let residents know that fresh fish was being unloaded on the quayside? Or that in 1559 Elizabeth I granted the borough of Maidstone the privilege of owning the swans on its own waterways, all other swans in the country officially belong to the Queen.

Producing this book has afforded me a rare opportunity to revisit many old haunts and many new locations. In so doing I have gained new insights and revelations about my beloved home town. In conclusion I believe that whatever your knowledge or experience of this wonderful borough is, you will find something entertaining and/or of interest within these pages.

1. Megaliths, Monuments and Memorials

Within the borough of Maidstone are twenty-seven monuments of national importance comprising archaeological sites, historic buildings and ancient monuments. There are also many memorials to people, places and events that have shaped the town's history. While some locations and stories are known, others, along with their historic significance and cultural relevance, are less well recognised.

Mention standing stones, long barrows, or ancient burial tombs and thoughts turn to Stonehenge and other monuments found throughout the West Country. Yet, nestled along the lower Medway Valley, are the prehistoric remains of what was once an important and vast Neolithic cemetery. The chalk downs on either side of the River Medway north of Maidstone, hold the only group of megaliths in eastern England and the borough's oldest and best kept secret. There are no car parks, cafeterias or gift shops to mark these sites, which makes finding them more challenging but well worth the search. But having discovered them and the landscape in which they are set, you will not be disappointed.

Following part of a prehistoric trackway that once linked the Kent coast to the important religious complexes of Avebury and Stonehenge in Wiltshire, the Pilgrims Way is an historic pilgrimage route linking Winchester to Canterbury Cathedral. Near the Pilgrims Way in a field on Blue Bell Hill near Aylesford is an ancient burial chamber comprising three large upright sarsen stones of the kind used at Stonehenge, with a horizontal capstone rising to a height of almost 10 feet (3 metres). This is all that remains of a once mighty 230-foot (70-metre) long barrow, known today as 'Kit's Coty House'. It dates back 4,000 years to the Neolithic age and takes its name from the Dark Age prince Catigern, son of Vortigern, who, according to legend, died during the famous Celtic *Cit Coit*, or 'Battle of the Woods', fighting the Anglo-Saxons commanded by Hengist and Horsa at Aylesford in AD 455. Originally known as the House of Cati, the name has been corrupted to the present-day Kit's Coty House.

Once covered by a large earth mound that has long since disappeared, in 1885 it became one of the first sites in Britain to become a Scheduled Ancient Monument. A few years later metal railings were erected around the chamber, leaving the rest of the barrow unprotected. At its western end once stood a large upright stone known as the General's Tombstone. This stone was blown up in 1867 and removed to allow the field to be cultivated, resulting in the remaining barrow being ploughed away.

Tradition states if you place a possession on the capstone during a full moon, make a wish and then walk around the chamber three times, the wish will come true, but only if the object disappears. The famous naval administrator and diarist Samuel Pepys once visited the stones and wrote, 'Three great stones standing upright and a great round one lying on them, of great bigness, although not so big as those on Salisbury Plain. But certainly, it is a thing of great antiquity, and I am mightily glad to see it.'

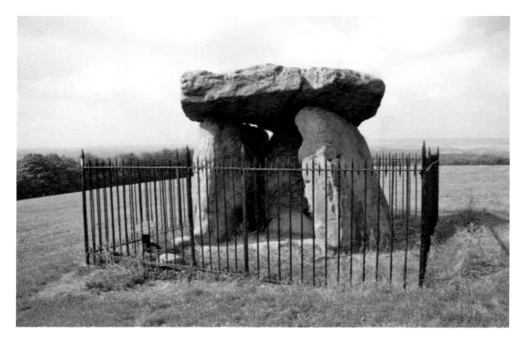

Kit's Coty House.

Further south, around 1,300 feet (400 metres) beside the Aylesford road, is the site of another Neolithic long barrow burial chamber, Little Kit's Coty, or Lower Kit's Coty. Deliberately toppled during the seventeenth century, all that remains today are the collapsed remnants of the chamber. Each time an attempt is made to count the stones a different number is reached, giving rise to its alternative name of 'the Countless Stones'. The site has reputedly been used to remedy instances of infertility.

To the west of Lower Kit's Coty, in the middle of a private vineyard, are the remains of another ancient chambered long barrow. Accompanied by two smaller stones, the aptly named Coffin Stone, a large flat sarsen stone 15 feet (4.5 metres) long by 3 metres wide, hugs the ground. In 1836, locals reported 'a sack full of human bones' including two skulls had been unearthed near the stones.

A short distance away, close to the high-speed train line and concealed in woodland, is the White Horse Stone, a large sarsen stone 10 feet tall by 2 feet wide, and almost 3 feet thick (3 metres by ½ metre by 1 metre). Dating from the sixth to eighth centuries, the white horse was the symbol of the Jutish Kingdom of Kent and the emblem of King Horsa, who also died during the 'Battle of the Woods' and whose name means stallion. Tradition has it that this stone marks his final resting place. However, the original White Horse Stone, like many of the chambers in the area, was broken up and ploughed out to allow more farming, leaving the incumbent stone to inherit both the name and tradition.

Located 1,000 feet (300 metres) north-east of the White Horse Stone on the edge of Westfield Wood is the site of the now lost Neolithic tomb Smythe's Megalith, or Warren Farm Chamber. Rediscovered in 1823 by farmworkers, it was recorded by local antiquarian

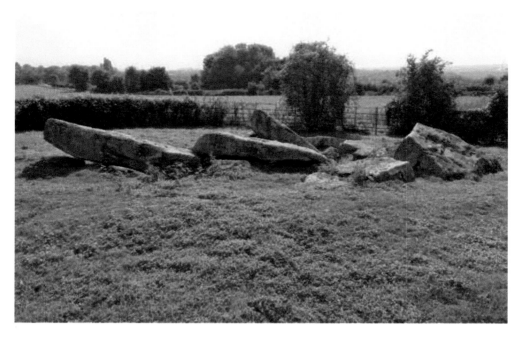

The Countless Stones.

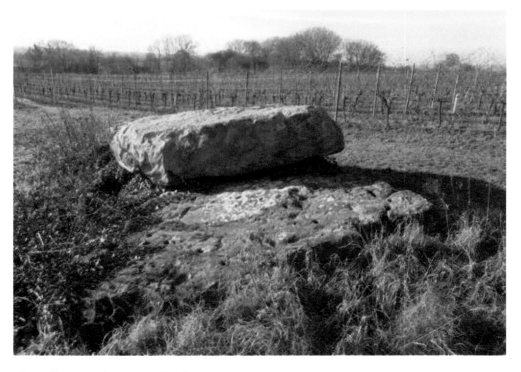

The Coffin Stone. (Courtesy of SM)

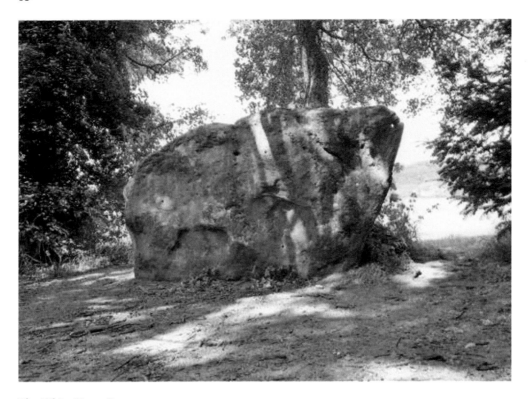

The White Horse Stone.

Site of Smythe's Megalith. (Courtesy of EDW)

Clement Smythe. He excavated the site and uncovered four irregularly shaped stones like those at Kit's Coty House. At a depth of around 5 feet (1.5 metres) he found the ancient remains of two adults. These stones were removed, but two further large stones were discovered nearby during ploughing in 1955. While the smaller stone was removed, the larger one was left behind and now lies below the ground.

The Romans, like other invaders who followed, settled among the fertile and resource-rich landscape of the borough, influencing the economic and industrial development of the area. However, apart from the open quarries and tunnels left behind from mining, visible evidence of their time here outside of the town's museum is almost non-existent. Fortunately, on occasion construction reveals rare glimpses of their lives, such as a section of a road, a roadside burial, a coin hoard or cemetery. The walled cemetery at Joy Wood, Langley, and the large bathhouse at Teston are such examples. Various villas and farmsteads have been discovered, and many artefacts have been preserved and displayed in the town's museum.

Many of the borough's historic buildings are listed and protected as monuments, while other structures act as memorials to significant people, places and events connected with the town. Although such tributes may last hundreds of years, often their importance becomes faded or forgotten, replaced with rumour and speculation. In this respect, there are several memorials to individuals and groups whose stories, although less well known, are worth mentioning due to their connection with key historic events.

In the High Street, a bronze cannon mounted on a gun carriage stands on a stone plinth – a trophy of war seized from the Russians during the Siege of Sevastopol (1854–55). It was presented to Maidstone in 1858 by Lord Panmure, the Secretary of War, and George Wickham, Mayor of Maidstone. Its serves as a memorial to the men of Maidstone and those of the Queen's Own Royal West Kent Regiment who died during the Crimean War. Passed by thousands of people each week, it has become a landmark known simply as 'the Canon'.

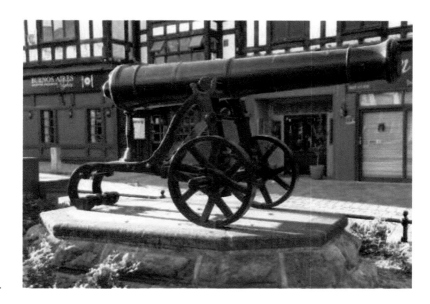

Russian cannon.

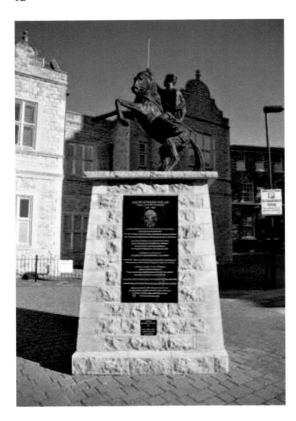

Memorial to Captain Nolan.

DID YOU KNOW?

At Tovil there is a memorial to the local scouts who died during the Second World War. Wing Commander Guy Gibson, VC, DSO and Bar, DFC and Bar, who led No. 617 Squadron in the 1943 Dam Buster raids on the Ruhr Valley in Germany is listed here. Stationed at West Malling, Gibson, a former scout, became an honorary member of the Tovil Venture Scouts in 1943 just days after the famous raid. Fifteen months later, he died during another bombing raid in Germany.

Another monument stands in front of the Holy Trinity Church, now converted into accommodation for a housing and homeless charity. A life-sized statue of a cavalryman sits on a rearing horse and honours Captain Louis Edward Nolan. One of the most famous cavalry officers of his day, he served in the Austrian Army and then with the British Army in India and the Crimea. An experienced rider and renowned equestrian reformist, he was riding master at Maidstone Cavalry Depot between 1841 and 1854 and attended the Holy Trinity Church. Nolan was blamed for giving the disastrous order

during the Crimean War that caused 600 men of the Light Brigade to charge into the wrong valley where they were fired upon by Russian artillery from three sides. Although killed during the now infamous charge and unable to defend himself, eventually blame was correctly attributed to his commanders, Lords Raglan and Cardigan. Within the church was an earlier memorial tablet to Nolan that read: 'His brother officers and other friends have erected this tablet as a slight tribute of their esteem and affectionate regard for the memory of one of the most gallant, intelligent and energetic officers in Her Majesty's Service.'

Following the undertaking of redevelopment work during the 1990s the tablet was supposed to have been removed and displayed at the Maidstone Museum. It disappeared, however, and its current location is unknown.

An equally tragic connection to the Crimean War is the little-known account of Major Charles Henry Lumley of the Queen's Own Royal West Kent Regiment. He bravely distinguished himself in action on 8 September 1855 at the Siege of Sevastopol, leading an assault at the battle of the Great Redan. His citation states:

Being among the first inside he was immediately engaged with three Russian gunners reloading a field piece, who attacked him; he shot two of them with his revolver, when he was knocked down by a stone, which stunned him for a moment, but, on recovery, he drew his sword and was in the act of cheering his men on, when he received a musket ball in his mouth, which wounded him most severely.

Having survived his injuries, Major Lumley was awarded the Victoria Cross (VC) – the highest award for bravery in the British Army, which is given for gallantry in the presence of the enemy. The award was presented by Queen Victoria at Hyde Park, London, on 26 June 1857. Tragically, and for reasons unknown sixteen months later, on 17 October 1858 while stationed at barracks in Wales, he took his own life with the revolver that had helped him win his award. His Victoria Cross and Legion of Honour Medal are on display at Maidstone in the Queen's Own Royal West Kent Regiment Museum.

Maidstone has another notable yet less celebrated connection with the Crimean War. Born in Maidstone, William Perkins is a forgotten and unsung hero who enlisted into the 11th Hussars in 1846. In 1854 he saw service in the Crimean War and was one of only three trumpeters that rode in the Charge of the Light Brigade. Perkins famously sounded the rally that caused the 11th Hussars and the 4th Light Dragoons to charge back through the Russian Lancers, during which action his horse was shot from under him. Having survived, he mounted a loose horse and continued the charge sounding bugle calls. After the war, in 1858 he was promoted to sergeant, and then trumpet major in 1864. Having left the army, he died peacefully at Essex in 1899.

In the town's Jubilee Square, standing, where for hundreds of years the ancient market cross stood, is a drinking fountain under a canopy enclosing a life-sized marble statue of a regal-looking lady, of slight build and almost angelic in appearance, wearing an ancient Greek-style dress. Created by John Thomas, a prolific Victorian sculptor responsible for creating many important architectural sculptures and statues, including the chapel in Regent's Park, London. Passers-by not taking time to inspect the monument would be

forgiven for not immediately recognising the figure as that of a young Queen Victoria; or for noticing there is a plaque on the monument's base that states the fountain was the gift from Alexander Randall to his native town. Maidstone-born Randall was the founder of the Kentish Bank and high sheriff to the town in 1862.

Randall was said to be graced by sociality and kindness, which enabled him to exercise great influence in the town and neighbourhood. He was ever zealous in promoting the welfare of others and took great pride in upholding his civic duties and ensuring that the prosperity of the town and its trade were dispersed fairly. He was generally very popular as a magistrate and a gentleman, and he said of himself that he allowed his sense and sympathies to steer him clear of the meanness of the hoarder and the offensive bearing of the upstart. Sadly, all that remains of his career, achievements, generosity and many philanthropic acts is this gift to the town.

Within All Saints Church is a memorial to George Washington's great-uncle Lawrence Washington. It includes the family's coat of arms, which bears a remarkable resemblance to the flag of the United States. On the outskirts of Lenham village, on the slopes of the ridge above the A20, is one of the nation's most unusual and eye-catching war memorials. A 190-foot-high (58-metre) chalk cross carved into the hillside in 1922 commemorates forty-two local men who died during the First World War. Designed by Mr C. Groom, headmaster of the village school, the cross now serves as a memorial to those who died in both the First and Second World Wars.

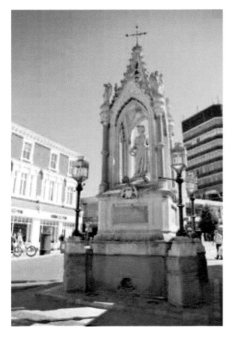

Above left: Drinking fountain.

Above right: Washington's coat of arms.

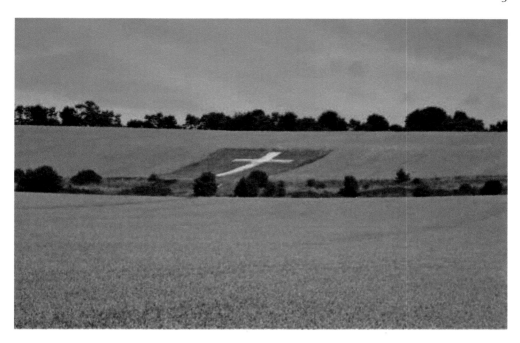

Lenham Cross.

Mote Park has two unusual memorials. The first commemorates Lord Romney, Lord Lieutenant of Kent, and was built from public subscriptions donated by men of the county's Volunteer Corps to mark their high regard and grateful thanks for his 'constant attention to them', particularly his unparalleled hospitality during the royal review at the park on 1 August 1799. At his own expense, Lord Romney served a huge feast for George III and Queen Charlotte, the different branches of the royal family, the great officers of state, the principal nobility and gentry of the realm, 6,000 men of the Volunteer Corps and thousands of spectators. Described as a glorious day for the county and without parallel, the feast included 60 lambs, 700 fowl, 300 hams, 300 tongues, 220 dishes of roast beef, 220 meat pies, 220 joints of veal and 220 fruit pies. The surplus was distributed to every cottager in the neighbourhood and among 600 poor families in the town. The Volunteers' Memorial Pavilion was erected in 1801 on the east side of Mote Park. The inscription reads 'This Pavilion was erected by the Volunteers of Kent as a tribute of respect to the Earl of Romney, Lord Lieutenant of the County, MDCCCI.'

There is an oak tree in the park that serves as both a memorial to the men who lost their lives during the Second World War and as a personal dedication to one man. Upon the tree, a metal plate is dedicated to Richard Charles Chapman, a lance sergeant in the 1st Battalion, Grenadier Guards, who died on 3 April 1945 and is buried in Reichswald Forest War Cemetery, Nordrhein-Westfalen, Germany. The tree was grown from an acorn by Richard's father, who had collected it when he first visited the cemetery after the war. The tree was presented to the town council and planted by the Mayor D. M. Relf in February 1958. Mrs Relf was also the first female Mayor of Maidstone.

Volunteers Memorial.

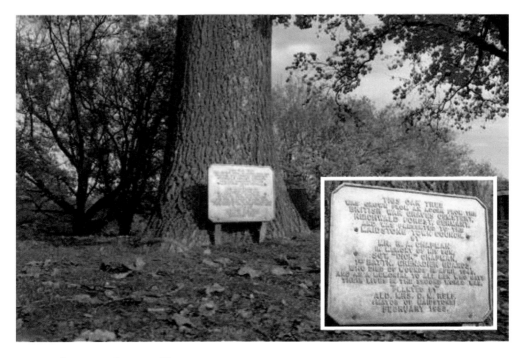

Memorial to Lance Sergeant Chapman.

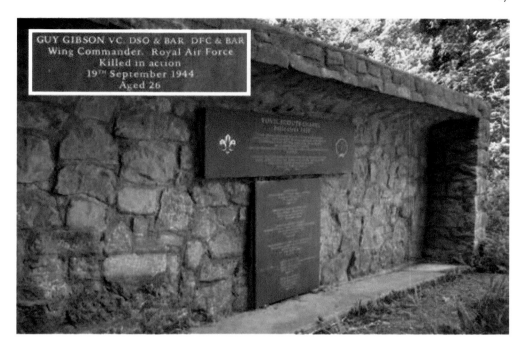

GUY GIBSON V.C. DSO & BAR DFC & BAR
Wing Commander. Royal Air Force
Killed in action
19ᵀᴴ September 1944
Aged 26

Memorial to Wing Commander Gibson.

Inset: Close-up of memorial.

DID YOU KNOW?

Maidstone Cemetery contains 247 Commonwealth War Graves Commission burials from the Second World War, including fifteen New Zealand servicemen, eight Canadian servicemen, two Australian airmen and one Dutch sailor. Additionally, there are seventeen German servicemen buried there. A special memorial commemorates seven British servicemen in the cemetery buried in adjacent graves who could not be individually identified. The men were among sixteen killed by a German bomb dropped on Detling aerodrome in August 1940.

2. Medieval Maidstone, Murder, Meetings and Markets

Maidstone has many interesting commercial, political, religious and industrial links to its medieval past. Nestled quietly throughout the borough's landscape are many splendid features and often overlooked buildings that hold many treasures, intriguing stories and secrets.

The River Medway is central to the history of Maidstone and was a source of income and sustenance, featuring in many of the town's successes, failures and disasters. In AD 666, Egbert, first King of Kent, murdered his nephews Etheldred and Ethelbert and used the Medway to dispose of their bodies. During the medieval period many large creatures were caught in the river: a large seahorse was trapped in 808, a large whale landed in 824, two porpoises and a whale were caught in 909, and in 1056 a whale measuring 34 feet was taken from the river.

In 999 a Danish force of Vikings laid waste to large parts of West Kent as they navigated the Medway towards Maidstone, their likely target its minster church of St Mary – a Viking bearded axe found at Sandling Lane may testify to their arrival. Bursting its banks in 861, the river flooded, killing several cattle and in 1114 it dried up, allowing people to pass over it on foot. People again passed over the river when it froze in 1454.

The River Medway.

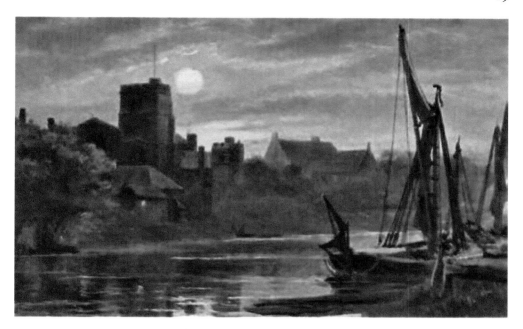

A wharf on the Medway.

Once tidal, the Medway brought prosperity to the town. Free wharves for loading and unloading barges and small sailing vessels were built that still exist today along Fairmeadow and the bottom of Faith Street. The town was linked to surrounding villages at Fant and the borough of Westborough by a bridge 11 feet wide.

The first tangible evidence of Maidstone's existence as a medieval settlement was discovered in 1823 during excavations at Wheeler Street, which uncovered Anglo-Saxon burials dating to the seventh century containing weapons, jewellery and pottery. Large numbers of burials of that period were discovered during the 1960s at Aylesford. At Lenham, in 1946, the graves of three Saxon warriors were discovered during restoration work at the pharmacy. It is thought the corner of a sixth-century cemetery was uncovered, revealing the remains of two men and a woman buried in military regalia and with weapons.

Before the Norman invasion in 1066, Maidstone was a thriving Saxon village; however, sources differ concerning the origins and meaning of its name. Medwegstun, after Medwege (the middle river), is plausible, as are Maeidesstana ('stone of the maidens') and Maegdanstane ('stone of the people'), suggesting a connection to the nearby megaliths where gatherings and ceremonies were held. In 1086 the Domesday Book names the village as 'Medestan/Meddestane' and during the centuries that followed various changes have resulted in today's Maidstone.

Maidstone had long been a central place for the local people to meet. The ancient site of Penenden Heath acted as an assembly for the Shire Court and to muster forces, while the centuries-old Church of St Mary was a religious draw. Replaced by All Saints Church in 1395, it was described in 1070 as one of the most important and wealthiest churches

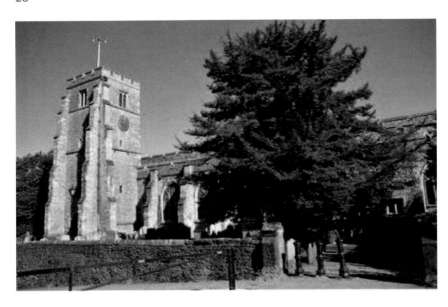

All Saints Church.

in Kent, attracting people from far and wide. By the thirteenth century, Maidstone was a prosperous town and in 1261 received its first charter, allowing markets every Thursday. In 1549 the town became incorporated, gaining more freedom to administer its affairs locally. Its position on the River Medway meant it was perfectly located to transport goods, vegetables and fruits by river to London. As it developed into a market town people travelled from London, the surrounding counties and across Kent to trade and take part in its annual fairs. The market, initially held in Lower High Street, was moved to Earl Street, then to Fairmeadow and finally to Lockmeadow, where it remains today.

DID YOU KNOW?

Cloth making was a very important industry in Kent during the medieval period and when fourteenth-century immigrants from Flanders arrived, they brought new ideas that advanced the industry's productivity. The weaving took place in workshops called Clothiers' Halls, after which it was 'fulled' using fuller's earth, which was excavated mainly from around the Maidstone area, further enhancing the town's status. At Headcorn, a large cloth hall survives near to the village church.

In addition to its agricultural interests, the town generated income from other industries such as tanning, with hides being transported to Maidstone along the Medway from London. Since Roman times the townspeople had felled timber and excavated chalk and

limestone (Kentish ragstone). Ragstone was used throughout the county to build churches, castles and other prominent buildings and sent via the Medway to London where it was used in many buildings, including Hampton Court, the Tower of London and Westminster Abbey, which needed so much ragstone that a royal decree was issued that none would be carted to London for any other purpose until the abbey's completion. However, this didn't stop Henry V ordering 7,000 ragstone cannonballs from Maidstone's quarries.

Many craftsmen worked in and around the town; among them wool dyers, shoemakers, tailors, blacksmiths, carpenters, coopers, butchers, brewers and bakers kept the town and surrounding communities thriving. The town continued to expand, and by the early fourteenth century its population had reached around 2,000; however, the first instance of bubonic plague in 1348–49 reduced the population to around 1,400. The town's economy also benefited from holding the manorial, hundred and county court sessions, which drew complainants, petitioners, jurors and others from across the region. This in turn benefited crafts, trades and urban services such as inns and alehouses who provided accommodation, food and refreshment. The opportunities presented by a continuous influx of visitors to generate an income was not restricted to established licensed businesses. Many women were brewers too, and at its height a third of housewives were brewing for sale; many others did so illegally.

DID YOU KNOW?

The effect of the Black Death on Maidstone, while unrecorded, would have been severe, as it killed 30 per cent of England's population. In May 1349 at the Abbey of Malling, Abbess Isabel Packham died of plague; elected later the same day was Abbess Benedicta de Grey, who died that evening of plague. The next abbess elected died of plague three weeks later.

Newark Hospital, founded in 1261, is the oldest building in the town and was used by pilgrims crossing the Medway on their journey to Thomas Beckett's shrine at Canterbury. Later dedicated to St Peter, St Paul and St Thomas, it became known as the Newark of Maidstone. Redundant after the Reformation, it was restored and enlarged between 1836 and 1837, and again in 1905 and 1951. The building is no longer a church and is now a nursery school. In Mill Street is one of two ancient millponds that once served the Archbishop's Palace and nearby, hidden under the modern road, are the preserved remains of a thirteenth-century stone bridge that still allows water from the River Len to flow.

The Archbishop's Palace was one of five built between Canterbury and London in 1348, and many of the buildings and its grounds are preserved. The tithe barn and former stables, built around 1397, are today home to the town's Carriage Museum, and house a unique collection of horse-drawn vehicles, considered the best in Europe.

Left: St Peter's Church.

Below: The archbishop's mill pond.

Medieval Bridge and the River Len.

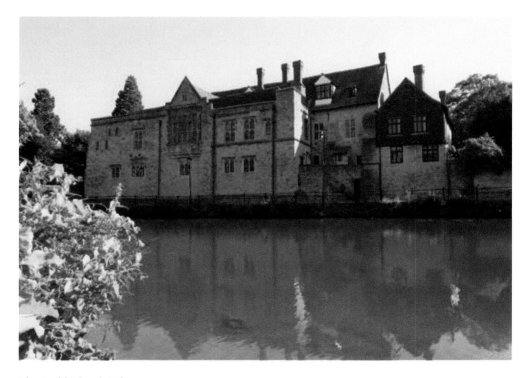

The Archbishop's Palace.

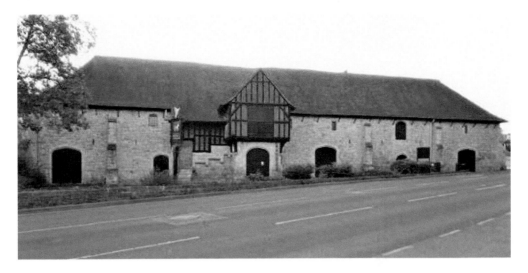

The Archbishop's Stables.

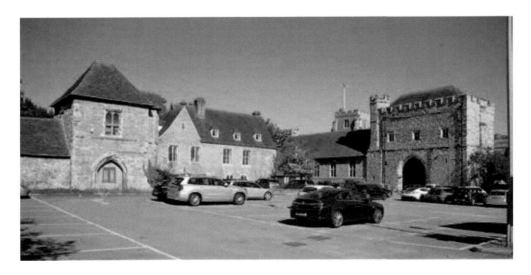

Part of the College of All Saints.

The College of All Saints formed part of a wider complex of medieval buildings, built in 1395 for housing priests attached to All Saints Church. It became an important spiritual and intellectual centre for the whole county and today remains one of the most complete and impressive collections of medieval buildings in England.

Corpus Christi Hall, built in the fourteenth century, was originally owned by the Corpus Christi Fraternity, a society of local tradesmen who regulated business, observed certain religious services and employed a chaplain to pray for their souls when they died. The guild also supported members in sickness, infirmity and old age. The fraternity lasted

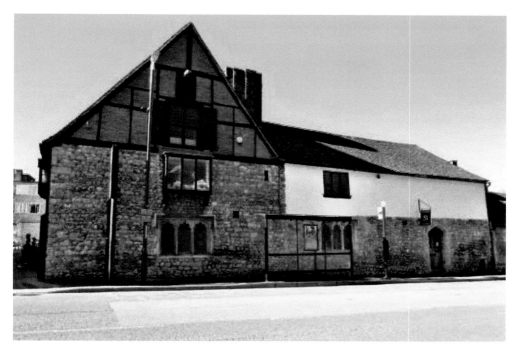

Corpus Christie Hall.

until 1547 when it was seized by the Crown during the suppression of religious guilds and used as a grammar school until 1871. Bank Street is typically medieval in its layout, with many shops dating from the fifteenth century. Maidstone's connections with its medieval past are not confined to the town, and throughout the borough many historic sites and constructions remain.

Few villages epitomise medieval Maidstone more than Lenham, with its manor houses, halls, church and tithe barn, which once belonged to St Augustine and was originally one of a pair – the other burnt down in 1962. The market square and the buildings that surround it are typically medieval in design, framed with Wealden timber and fitted with tall windows and king-post roofs. The Red Lion and Dog and Bear medieval hostelries remain, with the latter being a clue to a long-forgotten pastime.

On the village green at Offham there is an original quintain, a post with a revolving crosspiece that has a target at one end and a sandbag at the other end, used by knights as a target in tilting. Originally used by the Romans as a form of military equestrian training, it became popular with knights during the medieval period to practise their jousting.

The great stone barn at the site of Boxley Abbey is 183 feet (56 metres) long and was originally used by the abbey as a hospitium, where hospitality was a divine right of the guest and a divine duty of the host. It was later used as a tithe barn and is the only surviving structure. The abbey became infamous for its role in defrauding pilgrims, faithful parishioners and even a young Henry VIII with a religious relic known as the Rood of Grace, which people would pay generously to view. A wooden crucifix,

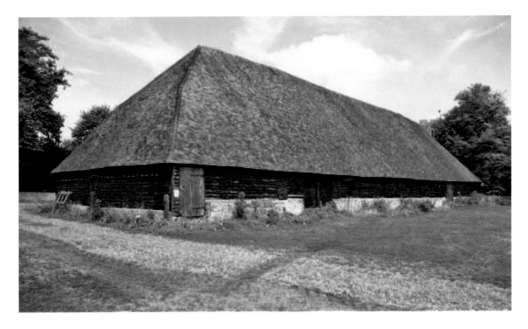

Tithe barn, Lenham.

Lenham Square.

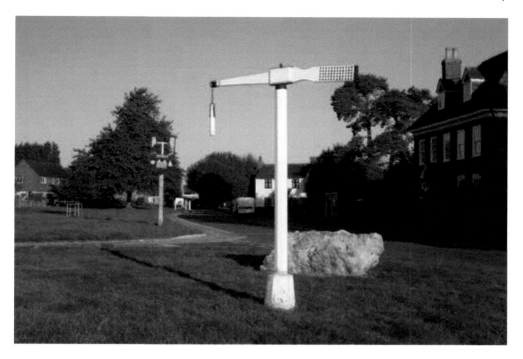

The quintain at Offham.

it was brought to the abbey on a stray horse, considered a miracle by the monks and turned into a shrine to be venerated. On occasion it would move, shed tears, foam at the mouth, turn, nod its head and make various facial expressions and talk. The monks also adopted the practice of hiring imposters to infiltrate crowds as witnesses to earlier cures. During the dissolution of monasteries in 1538, the rood was examined and found to be an ingenious contraption of levers, wires and rods that made the eyes and mouth move like a living thing. It was displayed in Maidstone market to prove the fraud and subsequently destroyed and sent to London for burning. Additionally, an effigy of the infant St Rumbold, which could only be lifted from its plinth by the righteous, was also exploited by the monks, who operated a hidden spring under the statue according to the size of the cash gift provided.

Several fine examples of fourteenth- and fifteenth-century farmhouses survive. Among them are Rabbit's Cross Farmhouse, Boughton Monchelsea, Dunbury Farmhouse, Chart Sutton, Stoneacre, the Yeoman farmer's house, Otham and Rugmer Hill Farmhouse, Collier Street, each providing a unique glimpse into rural housing at that time.

Among the medieval structures in Maidstone are seven bridges spanning the River Medway. Three stand out: East Farleigh, considered the finest example in England; Yalding is Kent's longest medieval bridge; and Teston has substantial cutwaters. At St Peter's Church, Boughton Monchelsea, the views are spectacular, and the cemetery boasts one of the oldest lychgates in England; also, near Leeds Castle are the ruins of a barbican and thirteenth-century dam gate.

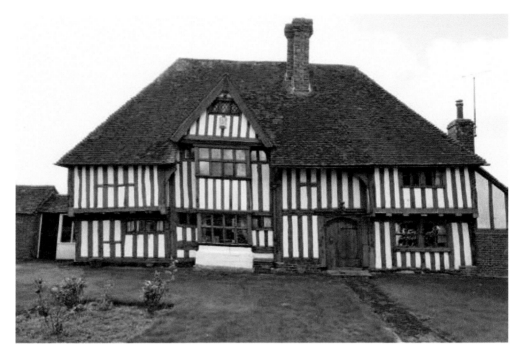

Rabbits Cross Farmhouse.

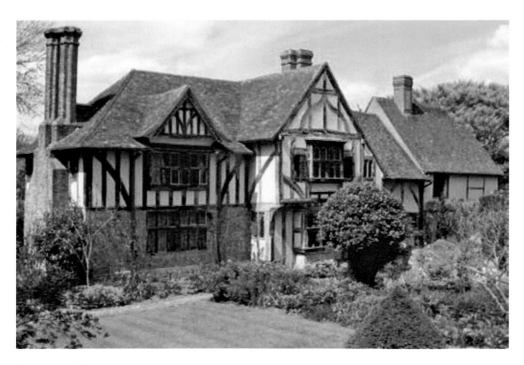

Stoneacre, Otham.

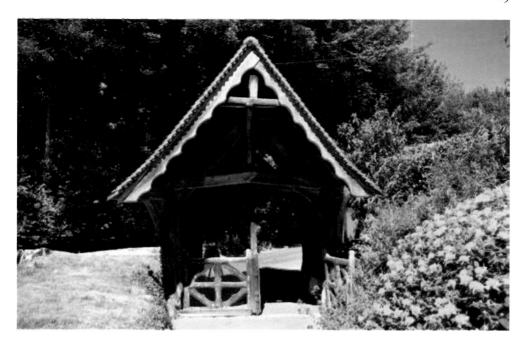

Lychgate, St Peter's.

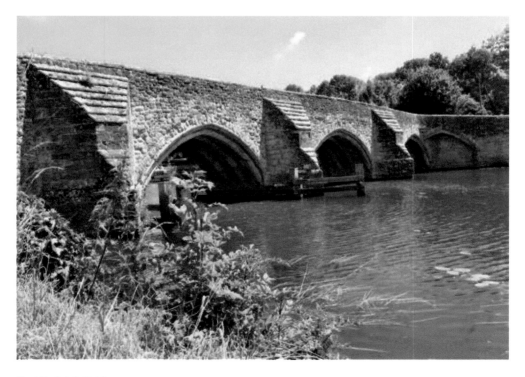

East Farleigh Bridge.

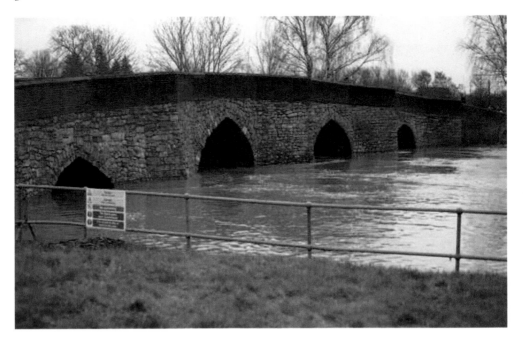

Yalding Bridge.

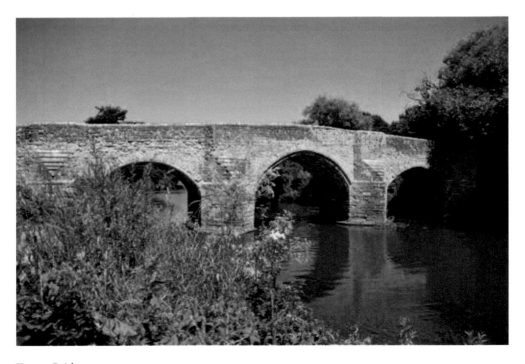

Teston Bridge.

The Cloth Hall, Headcorn.

DID YOU KNOW?

In addition to its holy rood, Boxley Abbey once contained a religious relic that made the abbey a popular medieval pilgrimage site. Encased in an ounce of silver was the little finger of St Andrew, one of the first disciples of Jesus, who was crucified in Greece on an X-shaped cross in AD 60.

3. Riots, Rebellions and Revolts

The contribution made by some of Maidstone's inhabitants upon England's turbulent history is not insignificant, and areas across the borough have witnessed key events that have shaped that history. Few events are so short, sudden and dramatic as the great insurrection of June 1381 known as the Peasants' Revolt. The effects of war, poverty and the Black Death upon the general population at that time meant life was extremely difficult. An added tension that interfered with their livelihoods was an obligation to give free labour on church estates. Tensions reached breaking point when an ongoing war with France caused Richard II to introduce a new poll tax. An already aggrieved populace refused to submit to the demands of tax collectors any longer, and united to rise in rebellion. Between 30 May and 28 June half of England was alight, and it seemed that complete anarchy would bring the old order of things crashing down.

In Maidstone, 15,000 angry and reckless insurgents assembled under the command of Wat Tyler. A former sergeant-at-arms to Edward III, he was quick-witted, self-reliant, ambitious and spoke in an insolent and grandiose way. A local hero who'd legitimately killed a tax collector for assaulting his daughter, he began to organise the uprising and quickly established authority and discipline among his followers by executing thieves among their number. Intent on doing away with the manorial system and destroying those responsible for the new poll tax and the disastrous war with France, Tyler led the rebels to Rochester. There they besieged and captured the castle before moving to Canterbury where they rioted, looted and beheaded the archbishop and three traitors. On route to London, the rebellion, gathering in number and momentum, returned to Maidstone where they beheaded John Southalle, a freeman, ransacking and burning his and other wealthy landowners' homes.

The rebels released prisoners from the gaol within the Bishop's Palace. Among their number was a radical priest named John Ball, known as 'the Mad Monk', a self-proclaimed visionary and prophet who, during twenty years of itinerant preaching, had spread discontent and denounced the wickedness of the higher clergy. Ball became their chaplain and was much revered, having instructed them to get rid of all the lords, the archbishop, bishops, abbots, priors, most of the monks and canons, and to distribute their possessions among the congregation.

Tyler led a 100,000-strong rebel army into London where for two days he showed his power. Dominating the city, his army captured the Tower of London and caused havoc, murdering and looting along the way. On 15 June Tyler met with Richard II and William Walworth, Mayor of London. During the meeting an argument arose causing Walworth to wound Tyler and one of the king's squires stabbed Tyler in the stomach. The rebellion was over and the landless adventurer, who during the crisis had bathed his hands in blood and pushed his way to the top, was dead. Ball was captured, hanged, drawn, quartered, and then beheaded as a traitor.

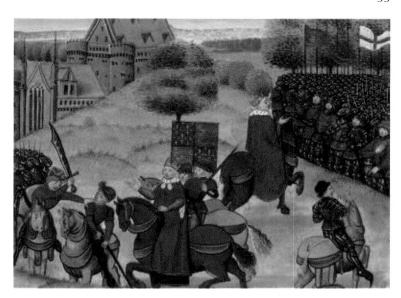

Death of Wat Tyler.

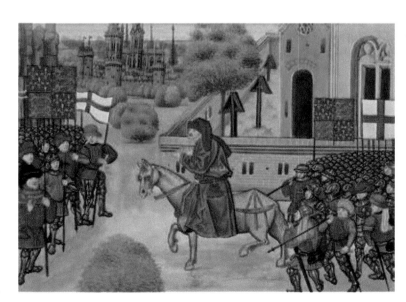

John Ball
encouraging rebels.

The town's next experience of rebellion came in 1450. The Hundred Years' War had depleted the English Treasury and the royal coffers were constantly in need of replenishment. The people were taxed heavily by greedy royal officials who lined their own pockets at the expense of a proper system of tax administration. To worsen the situation, England had lost all its territories in France, causing thousands of landless men and women to return to Kent and Sussex as nomadic beggars. Incensed and outraged at the king's poor governance and unjust taxes, the rich and poor came together to put an end to the situation.

At 6 feet 5 inches tall Jack Cade, a former soldier, was a giant of a man who emerged as the rebellion's leader. Full of hatred at the system and made bitter by the death of his son, he was an ungovernable alcoholic with nothing to lose. Cade rampaged across Kent murdering government and royal officials, and in June 1450 he stormed Maidstone with 5,000 peasants and freemen. Having led an attack on the gaol at the Archbishop's Palace, he beheaded the High Sheriff of Kent and stuck his head on a pole, then hanged the gaoler and fifty members of the militia from trees within the palace gardens.

Standing at the town's market cross, Cade called on the men of Maidstone to join the revolt before moving to Sevenoaks where he attacked and beat government troops. Having stormed London Bridge, he proclaimed himself Mayor of London and executed the Lord High Treasurer, James Fiennes, 1st Baron Saye and Sele, and his son-in-law William Crowmer, both of whom had been Sherriff of Kent. Cade's continued lawlessness alienated Londoners who eventually drove the insurgents from their city. The government persuaded most of the rebels to disperse by offering them a pardon, but Cade continued his resistance.

Pursued by the future Sheriff of Kent, Alexander Iden, Cade was wounded during his capture and died while being transported to London. Cade's body underwent a mock trial as a warning to others, and was beheaded at Newgate. His body, having been dragged through the streets of London by a horse, was quartered. Limbs were sent throughout

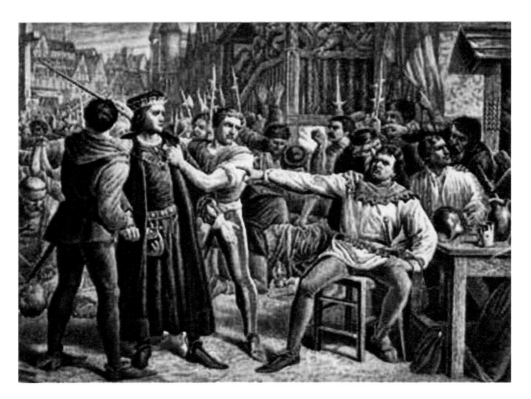

Jack Cade.

Kent to various towns and locations believed to have supported the rebel uprising. Although suppressed, Cade's uprising weakened Henry VI's authority, leading to the Wars of the Roses between the houses of York and Lancaster.

DID YOU KNOW?

Jack Cade had several identities. He was known to the authorities as both John Mortimer and John Amendale. He referred to himself as the cousin of Richard, Duke of York and as John Aylemore, a physician who, in 1449 while under the patronage of Sir Thomas Dacre of Surrey, allegedly summoned up the Devil and later murdered a pregnant woman. This caused him to flee to France. Jack Cade's rebellion was later dramatised by William Shakespeare in his play, *Henry VI, Part Two*.

Maidstone would feature in another revolt against King Richard, this time Richard III in the Buckingham Rebellion of 1483. A collection of uprisings in England and parts of Wales against Richard III, the rebellion assembled at Penenden Heath, the gathering point for this short-lived and ill-fated rising. On 18 October the 'Maidstone Sector', as it has become known, saw 5,000 men rallied from Surrey, Sussex and Kent take up arms and march to Rochester and onto Gravesend to link up with Henry Stafford, 2nd Duke of Buckingham, in London. Stafford was bringing an army across from Wales via the south-west. Thwarted by bad weather, he was unable to cross the River Severn and while waiting to do so his whereabouts was betrayed, resulting in his capture and execution at Salisbury. In military

Duke of Buckingham attempting to cross the River Severn.

terms it was a complete failure; however his death deepened feelings against Richard as king, causing many notable figures to join Henry Tudor's camp. (Henry Tudor would later become Henry VII and father to Henry VIII.)

In 1549, peasants across England revolted against the enclosure of land by the aristocracy. At Maidstone many people rebelled in response to local enclosures, but despite their protest and several peasant deaths, the lands remained enclosed. The next significant rebellion to take place was the Maidstone Rebellion of 1648 or, as it has become known, the Battle of Maidstone.

The incarceration of Charles I in November 1647 incensed his supporters, and when the 1644 legislation banning Christmas was reinforced on Christmas Day 1647, it sparked the Plum Pudding Riots. These lasted until early January 1648, when a force of 3,000 Roundheads ruthlessly quashed them. The riots sparked a fire of rebellion in Kent that five months later would ignite into the Battle of Maidstone. The aristocracy of Kent petitioned local authorities for the return of the king to power, and for the feared New Model Army to stand down; however, this was ignored and, with continued reinforcement of Puritan law, created a catalyst for the uprising to begin.

In mid-May 1648, the same aristocracy, aided by rebels within the Parliamentary Navy under the command of the Earl of Norwich, seized strategic towns and fortifications across the South Downs while rebel reinforcements from Surrey and Essex were mobilised. Parliament's response was to counter them with a force of 8,000 tried and tested fighters led by Sir Thomas Fairfax. Fairfax left London bypassing Aylesford, where part of the rebel force was garrisoned, and Rochester, a stronghold capable of causing serious resistance and delay. Instead he headed for Maidstone, where the Earl of Norwich had garrisoned 3,000 men in the town, with a further 7,000 camped outside.

On 1 June, Fairfax entered Maidstone via Farleigh Bridge where, after some resistance, he eventually engaged with Norwich's main force. Despite their inexperience, Norwich's men offered heavy resistance and only following serious fighting, retreated, leaving the way into town clear. The fighting took place in torrential rain and Fairfax planned to attack early the next day. However, having met fierce opposition on the town's outskirts, he decided to push on and finish the fight that night. To Fairfax's surprise, the fight within the town was bloody and furious with Royalists fighting harder than expected, defending barricades and putting their artillery to good use. They fought street by street as the New Model Army slowly forced them up Gabriel's Hill and along Week Street into the churchyard of St Faith's. There they made a heroic last stand until overrun by Fairfax's forces. During the fighting 300 Royalists died and 1,400 were taken prisoner. Fairfax lost just eighty men.

Gaols, by their very nature, have a long association with rioting as a means of changing conditions, treatment or escaping. Maidstone's gaols prove no exception with the first and most determined attempt to break out coming at the felon's gaol on 7 August 1765. Five prisoners – Simon Pingano, Andrew Benevenuto, Samuel Matthews, John Knight and Thomas Rogers – made their attempt while being escorted unhandcuffed by their gaoler James Stephenson to his parlour for divine service, conducted by the chaplain of All Saints Church, John Denne.

At three o'clock, Stephenson was attacked by Pingano, who seized his sword and stabbed him in the stomach, while Benevento assaulted the chaplain, rendering him

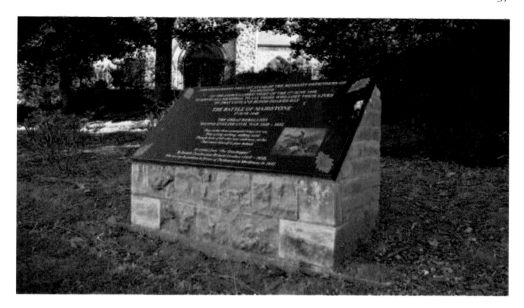

Monument of the Battle of Maidstone.

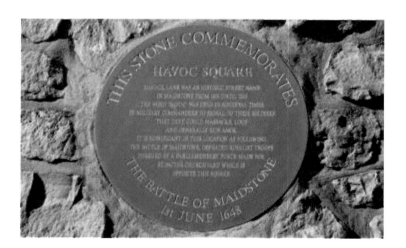

Havoc Square plaque.

unconscious. The group took possession of firearms and cutlasses hanging in the hall and, having seized John Hulden, keeper of the keys, liberated all the prisoners and forced Hulden to fetch them various liquors. With the alarm raised, members of the town began firing on the gaol, and during an exchange of fire a publican and breeches maker were killed. Around eight o'clock Pingano and Benevento led a large gang out the gaol and headed into the town, firing upon those gathered in East Lane attempting to prevent their escape. Several people were wounded, including Tom the Drover, a well-known character who received a head wound that permanently deranged his senses, causing him to hang himself later that year.

They made their way towards Plaxtol, and later that evening were pursued by a party of soldiers from Maidstone. Within days, ten of the escapees were captured in Rove Wood after a firefight, in which ringleaders Pingano and Benevento were killed. Their bodies were taken to the gaol where the Chaplain Denne was found, still unconscious, under a heap of rubbish. The following day Stephens, the gaoler, died. A free pardon was granted to three prisoners who declined to join the riot; the remainder were tried and executed on Penenden Heath in November 1765.

In the early nineteenth century 'Captain Swing' was the fictitious name used to sign threatening letters during the Swing Riots of 1830, and represented the hardworking tenant farmer driven to destitution and despair by social and political change. Agricultural workers in southern and eastern England were protesting against agricultural mechanisation and harsh working conditions. Maidstone experienced several incidents of vandalism around the borough, with barns and haystacks being set alight. The most serious, yet least remembered, was the Battle of Bottlescrew Hill at Boughton, near Loose, on 30 October 1830. Recognising the seriousness of the unrest, local magistrates sought to appoint large numbers of additional special constables, summoning 300 farmers and other persons to the Bull public house in Gabriel's Hill to be sworn in. Most refused, claiming they were afraid of the group now known as the Incendiaries, and only forty took the oath.

Having gathered at Sutton, a gang of 300–400 labourers made their way to Linton Place where they were supplied with refreshments, during which they let it be known they were heading to Maidstone. Receiving news of this, the magistrates, short of constables, called for military assistance to end the march and at 2 p.m., accompanied by a number of gentlemen on horseback, forty cavalrymen, the mayor and town clerk, they set off in a carriage towards the quarries at Boughton to intercept the march.

Arriving at Bottlescrew Hill, they saw the labourers gathered on the opposite hill armed with short sticks and other heavy bludgeons. The military remained at a discreet distance while the mayor and others headed out to meet the mob. During a warning that their conduct was illegal, a man called Adams climbed upon the shoulders of another man and began haranguing the mayor. A magistrate called for them to disperse and when they didn't, the Riot Act was read. Adams continued berating the party and a violent fight broke out, during which he and two others – Pattman and Hallyweel – were arrested. With a full-blown riot underway, the cavalry came into view, causing the rioters to scatter amid cries of 'Here come the Red Coats'.

On 5 November 1876, fuelled by indignation at how Chief Constable John Ruxton was policing the borough, a rioting mob marched through the town carrying an effigy of him. Reaching the Russian Gun, they burnt the effigy. A magistrate attempted to read the Riot Act, but was threatened with violence and retreated. At the same time, another mob attempted to free a prisoner by attacking the police station in Palace Avenue. Having smashed several windows, they were eventually dispersed when police charged them with wooden staves.

In July 1880 at Larkfield, a labourer called Richard Goodhen, having previously given information that resulted in the arrest of a local publican, became further despised by residents when he assaulted a young woman. Thirteen men surrounded his house and called him outside to be punished. He refused, so the gang attacked his house. Pulling

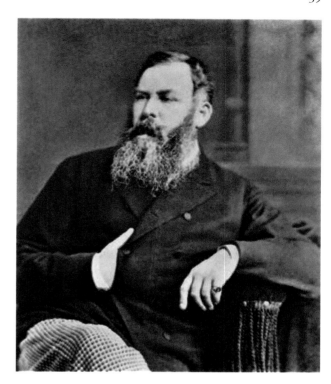

Chief Constable Ruxton.
(Courtesy of KPM)

the front door from its hinges, they smashed the window frames, pulled the roofing off and threw stones through the windows before rushing into the house brandishing sticks. Inside, they damaged furniture searching for him. Goodhen only managed to escape by cutting a hole in the ceiling and entering his neighbour's house. The offenders were later charged and convicted of riot and each were sentenced to three months' hard labour.

Gabriel's Hill and Week Street would once more be the scene of a running battle when, in 1981 following in the wake of national race riots, rampaging youths battled police as they smashed up the town.

DID YOU KNOW?

On the morning of 3 January 1919, 600–700 soldiers of the Queens, 3rd Gloucestershire and 3rd Wiltshire regiments marched down Maidstone High Street to the Town Hall. A deputation was received by the mayor who promised to forward their representations to the proper quarters. The demonstration had been preceded by interviews with their officers, during which the soldiers had demanded an end to unnecessary guard duties, drill and fatigues. Demonstrations of discontent continued during the afternoon until eventually their demands were agreed.

4. Sons, Daughters and Colourful Characters

Maidstone has been home and birthplace to many distinguished figures. Some individuals and their deeds are remembered through memorials and plaques, while others have had roads, parks or locations named after them. While their names live on, their stories and achievements often fade with the passage of time, whereas the actions of other less-renowned individuals, while equally significant, go uncelebrated. Their stories are too numerous to include here, and while some feature in other chapters, this chapter presents several of the town's more interesting sons and daughters, and colourful characters.

Among these are the infamous Mayor Andrew Broughton (1602–87), who in November 1648 was Clerk of the Court at the High Court of Justice for the trial of Charles I (King of England, Ireland and Scotland). Broughton read aloud the charge against the king, signed his death warrant and declared the king's death sentence.

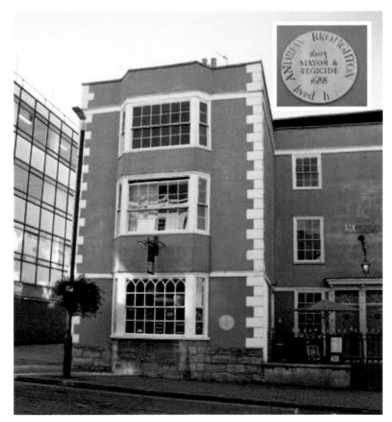

Andrew Broughton's house.

Inset: Plaque on the house.

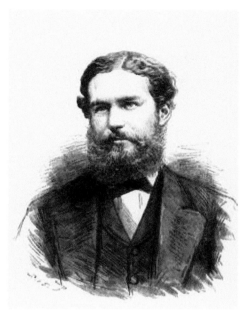

Above left: Lord Avebury. (Courtesy of the Chislehurst Society)

Above right: William Hazlett. (Courtesy of MMBAG)

There is also Lord Avebury (1834–1913), who introduced bank holidays to England; William Caxton (1422–91), England's first printer; William Hazlett (1778–1830), considered the most prominent essayist of his time, a passionate orator and radical romantic; and Sir Garrard Tyrwhitt-Drake (1881–1964), author, zoologist, circus and zoo owner, who was appointed Mayor of Maidstone twelve times.

DID YOU KNOW?

The surgeon chosen to sew Charles I's head back on and embalm him after his execution was Maidstone-born Thomas Trapham, who also served as personal surgeon to Thomas Fairfax and then Oliver Cromwell at the Battle of Worcester in 1651. Trapham died during an earthquake that devastated the island of Jamaica in 1692.

William Alexander (1767–1816): An English Painter in Imperial China

Born in Maidstone, Alexander attended Maidstone Grammar School before moving to London in 1782, where he studied art under renowned artists William Pars and Julius Caesar Ibbetson. In February 1784, he was admitted to the Royal Academy Schools where

William Alexander.

he honed his talent for painting, attracting attention from renowned artists of the day such as Sir Joshua Reynolds.

In 1792, he was chosen to accompany Lord Macartney's Embassy as a junior draughtsman on Britain's first diplomatic mission to China. Having made over 2,000 sketches, Alexander returned to England in 1794 where, through his drawings and watercolours, he offered Europe a better understanding of the habits, customs, architecture and people of China than any previous artists.

Following his return, Alexander worked for several years teaching landscape drawing, and in 1802 he was appointed professor of drawing at the Military College, Great Marlow, where he secured a post as assistant librarian and first keeper of prints and drawings at the British Museum. Alexander was much respected among his colleagues and in the art world. Although he continued drawing, he remained best known for his detailed images of China. Described as a 'man of mild and engaging manners with an active benevolence and unsullied integrity', he died suddenly on 23 July 1816. He is buried at St Mary and All Saints Church in Boxley.

John Braddick (1782–1865): A Slave Trader and Gentleman Horticulturalist

A resident of Boughton Monchelsea, Braddick came from a wealthy family of merchants, farmers and fruit growers with an infamous past. His great-grandfather was Captain John Braddick, a slave trader who, following dealings with pirate Bartholomew Roberts (Black Bart) in 1721, was jailed for 'complicity with pirates'. Ten years later while captaining the brigantine *Recovery*, Braddick and his son were murdered by the crew during a mutiny.

In 1824, John Braddick, by then a shareholder in the British East India Company, moved to Boughton Monchelsea. Having initially made his fortune transporting slaves from Africa, he became a successful fruit grower and in 1827 built the mansion house Boughton Mount. However, his involvement with the slave trade appears to have continued. It was suspected that he kept slaves in the cellars of the mansion, where he fattened them up before taking them for sale at the London auction block.

James Ramsay (1733–89): The Unaccredited Abolitionist

By contrast, at Teston, Revd James Ramsay, having served as a ship's doctor in the Royal Navy, was a pioneer in the movement to abolish the slave trade. In 1759, while stationed in the West Indies, he witnessed the suffering of slaves aboard a ship struck down with dysentery; many of the slaves were so tightly packed they were gasping for air. With most of the crew and many slaves dead, he singlehandedly tended to over 100 slaves.

When an injury forced him to abandon his naval career, he became an Anglican minister working on the Caribbean island of St Kitts, where, to his detriment, he continued to criticise the plantation overseers for the harsh conditions and their brutal behaviour towards slaves. Exhausted by his struggle, he left St Kitts in 1777 and became rector of St Peter and St Paul Church in Teston in 1781. The following three years he worked on his essay, the 'Treatment and Conversion of African Slaves in the British Sugar Colonies'. He also published 'An Inquiry into the Effects of Putting a Stop to the African Slave Trade' in 1784. The first published anti-slavery works by a mainstream Anglican with personal experience of the suffering in slavery, his works became influential in generating support for the anti-slavery movement.

He became friends with abolitionists William Wilberforce and Thomas Clarkson and in 1788 published his 'An Address to the Public, on the Proposed Bill for the Abolition of the Slave Trade' for which he received new attacks on his character from the House of Commons. These events profoundly upset Ramsay and caused him to become unwell, dying the following year. His work had a major impact on abolishing the slave trade in the UK and his relentless influencing of major abolitionists of the day is often overlooked.

DID YOU KNOW?

James Ramsay was not Maidstone's only clerical abolitionist. Revd Dr Christopher Newman Hall LLB (1816–1902), aka the 'Dissenter's Bishop', was born in Maidstone and in later life became one of the most celebrated nineteenth-century English Nonconformists. During the 1860s, rejecting the British government's position, he passionately supported the north during the American Civil War. He wrote, 'England should side with the North, particularly because emancipation of the slaves is just.' He felt so strongly that he visited the United States during the Civil War and published a passionate anti-slavery speech, co-authored by Abraham Lincoln and Henry Ward Beecher.

Mary Honeywood (1527–1620): A Distinguished Daughter

Honeywood was born at Lenham and rests there in St Mary's Cemetery. At the time of her death in 1620, she was survived by 367 descendants. Lenham's most distinguished daughter had sixteen children of her own, 114 grandchildren, 228 great-grandchildren and nine great-great-grandchildren. She was renowned for her work visiting prisons and caring for sick and infirm inmates, notably people arrested for their Protestant beliefs. These included the Marian Martyrs and the English reformer John Bradford. Bradford was burnt at the stake for his beliefs in 1555, and out of compassion Honeywood attended his execution to ensure his death was quick.

Nicholas Wood (1585–1630): The Great Eater of Kent

This title was bestowed upon Harrietsham resident Nicholas Wood. A farmer and seventeenth-century glutton, he became famous for eating vast amounts of food in one sitting. When rumour of his prodigious appetite spread, he became a local hero performing at county fairs, festivals and by invitation at the homes of landed gentry. Among his many feats he reportedly ate a whole sheep raw, at another dinner he ate 363 pigeons in one sitting and at another he scoffed food intended for eight people. At Lord Wotton's invitation to dine, he ate eighty-four rabbits and at Sir William Sedley's, he ate food for thirty men. Wood won many bets, on one occasion he devoured a breakfast

Nicholas Wood.

comprising a leg of mutton, sixty eggs, three large pies and an enormous black pudding. However, on another occasion at Sedley's home he was beaten (possibly tricked) by a table of food so vast that it sent him into a catatonic state. The next day he was placed in stocks and mocked for not completing the meal.

Wood's greatest misfortune occurred at Lenham, where John Dale had bet him he could fill Wood's belly without spending over two shillings. Dale bought twelve one-penny loaves and soaked them in six pots of very strong ale. After only eating half the loaves Wood fell asleep, remaining unresponsive for nine hours. During his long and perilous career as a glutton, he endured many distasteful and dangerous practical jokes, losing all but one of his teeth after being tricked into eating a shoulder of mutton, bones and all. Having sold his estate to fund his travel and excessive eating he died in poverty in 1630.

Robert Fludd (1574–1637): The Last Alchemist

Robert Fludd was a true Renaissance man and the last alchemist, yet little is known about him. Born in Bearsted in 1574, he attended Maidstone Grammar School and then St John's College, Oxford, graduating in 1598. He spent the following six years travelling across Germany, France, Italy and Spain studying medicine, chemistry, the occult, philosophy and mechanics. Returning to England, Fludd became a member of Christ Church, Oxford, where in 1605 he received his Bachelor of Medicine and Doctor of Medicine degrees. He moved to London seeking admission as a fellow to the Royal College of Physicians. However, due to his insolent manner and contempt for medical practices of the day that promoted use of the four humours – black bile, yellow bile, blood and phlegm – to treat patients, he repeatedly failed the entrance examination.

Eventually, in 1609, he was elected a fellow and his London practice proved highly successful and facilitated the maintenance of his own apothecary. The success of his practice was due not only to his skills, but to what has been attributed to his mystical approach, magnetic personality and his ability to influence the minds of his patients, inducing a 'faith-natural', that supported the effects of his drugs. He also consulted the horoscope to anticipate critical days to treat a patient.

Despite his busy medical practice, Fludd was a prolific writer who became an influential member of the Fraternity of the Rose Cross and was associated with the School of Medical Mystics, who claimed to be in possession of the Key to Universal Sciences. His later writings described a medical practice almost devoid of chemical remedies, relying instead almost solely on prayer. This devotional medicine was supported by a theology derived from the secret mystical teaching of Judaism, which Fludd employed in a Christianised form. His most famous work is the *History of the Two Worlds* (1617–21). The two worlds under discussion are those of the microcosm of human life on earth and the macrocosm of the universe (which included the spiritual realm of the divine).

As a writer and thinker, Fludd was unique. He lived at a time that saw a separation in the world of medicine and of philosophy. Besides his philosophical writings, he wrote scientific, medical and alchemical books. The cause of his death is unknown, but he was consumed by his work and this may have contributed to his demise. Weak and believing the end was near, he methodically arranged his affairs and had prepared a special stone for his grave. He died on 8 September 1637 and was buried in Holy Cross Church, Bearsted.

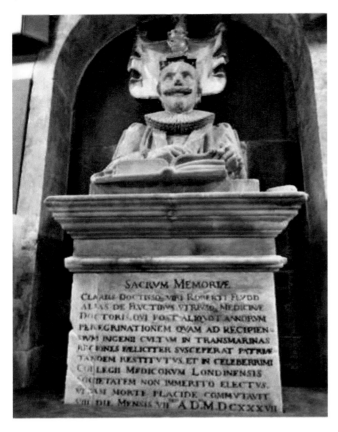

Robert Fludd.

Julius Brenchley (1816–73): A Gentleman Explorer

Brenchley was an explorer, naturalist, author and worldwide traveller who visited every continent except Antarctica, living among indigenous communities of Central, South and North America, North Africa, the Far East and Oceania.

Born at Kingsley House, Maidstone, on 30 November 1816, he was educated at Maidstone Grammar School, after which he entered St John's College, Cambridge. Following his graduation in 1843, he was ordained, serving as curate at Maidstone and Shoreham, Kent. In 1845, his father persuaded him to join him on a tour of Europe, following which he explored the world in search of knowledge and adventure. A passionate collector of art, ethnography and natural history, he became known as a 'gentleman explorer'. He experienced many dangers and endured many hardships during his travels. Attacked by hostile tribes and wild animals, Brenchley was once shot and wounded with an arrow fired by a North American Indian.

He sent a great number of artefacts back home, many of which are on display at the Maidstone Museum, along with the arrowhead that wounded him. In honour of his contributions to the museum's collections, they named a park behind the museum – Brenchley Gardens – after him. He died on February 1873 and is buried in the family vaults at All Saints Church, Maidstone.

Right: Julius Brenchley.
(Courtesy of MMBAG)

Below: Arrow removed from Julius
Brenchley. (Courtesy of CCCU and
MMBAG)

DID YOU KNOW?

The Brenchley family has a longstanding history in Maidstone, including the
formation of the Kentish Bank, Maidstone Breweries, the building of Maidstone's
almshouses. They were also mayors of Maidstone and benefactors to West Kent
General Hospital.

Lilian Bland (1878–1971): An Aviation Pioneer

Bland was born in Maidstone on 22 September 1878 and lived at Willington House, Willington Street. Around the turn of the century, she worked as a journalist and press photographer for various London newspapers. She lived an unconventional lifestyle for the period – smoking, wearing trousers and practising martial arts.

In 1906 she moved with her father to Ireland to live with her widowed aunt. While there, an uncle in Paris sent her a postcard of a Blériot monoplane, which inspired her to take up flying. No one in Ireland had made a powered flight, and getting an aircraft meant she would have to build one herself.

Following some background reading on aviation by the pioneer Wright brothers, Bland built and flew a model biplane. Later she built *The Mayfly*, a full-scale glider, from spruce, bamboo and canvas, which she completed early in 1910. She tested the machine by gliding it from Carnmoney Hill, strengthening it and adding heavier loads, until she believed it was strong enough to take an engine. Eventually she fitted *The Mayfly* with a 20-horsepower, two-stroke engine.

Her first successful flight was at Randalstown, County Antrim, in late August 1910, making her the first woman in Ireland to fly an aircraft, and *The Mayfly* the first powered biplane to fly in Ireland. She continued experimenting with further flights until her flying became a serious concern to her father, who saw it as unsafe and an unseemly pursuit for a young lady. He persuaded her to give up *The Mayfly* in exchange for a car, and by April 1911 Bland was running her own car dealership in Belfast. She returned to England in 1935, and settled in Kent in the 1950s. She died on 11 May 1971.

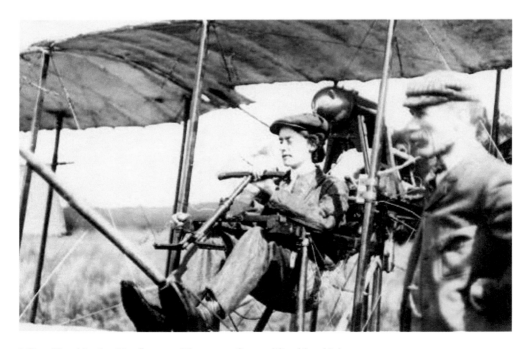

Lilian Bland in the *Mayfly*, 1910. (Courtesy of www.lilianbland.ie)

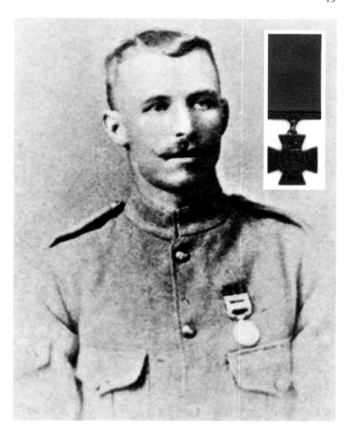

James Smith VC. (Courtesy of
www.vconline.org.uk)

Inset: VC medal.

James Smith (1871–1946): An Unsung Hero

Corporal James Smith of the East Kent Regiment is the only person from Maidstone to be awarded the Victoria Cross medal, which he gained during the First Mohmand Campaign in British India. On the night of 16 September 1897 in the Mamund Valley, north-west India, Smith, with other men, responded to a call for volunteers and followed two officers of the Royal Engineers into the burning village of Bilot to displace the enemy. During the fighting Smith was injured, but continued fighting steadily and coolly; he also helped to carry the wounded out of harm's way. When his commanding officer left to fetch assistance, Smith held the position until that officer returned, exposing himself to great danger as he directed the fire of his men. Smith died at Dartford on 18 March 1946.

Sydney Wooderson (1914–2006): The Mighty Atom

Wooderson was born on 30 August 1914 and was one of three brothers. His older brother Alfred and younger brother Stanley became good club runners, but Sydney, who attended Sutton Valence school, distinguished himself on the track.

Aged eighteen and weighing less than 9 stone (57 kilos), the 5-foot 6-inches (1.68-metres) tall runner became the first British schoolboy to break 4 minutes 30 seconds for the mile. He won the British mile title for five years until the outbreak of war in 1939. In 1934, he won the silver

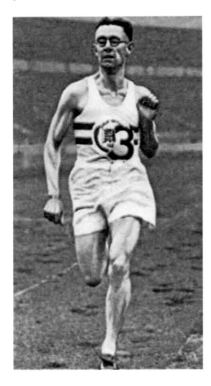

Sydney Wooderson.

medal in the 1-mile event at the British Empire Games. He also competed at the 1936 Summer Olympics in Berlin where he suffered a broken ankle and failed to qualify for the 1,500 metres final. However, in 1937, after surgery, he set a new world mile record of 4:06.4; the following year he set world records in the 800 metres and 880 yards, with times of 1:48.4 and 1:49.2.

Wooderson would have been more celebrated today had he been fully fit at the Olympic Games. The next two games in 1940 and 1944, when he would have been at his peak, were cancelled due to the war. There is little doubt that had he competed he would have been an outstanding Olympic champion. Wooderson was eighty-five when he received an MBE for his achievements, the result of a lengthy campaign by his friends. He died on 21 December 2006 and is buried in Wareham, Dorset. His headstone makes no mention of his MBE or his prowess and status as one of the greatest athletes of all time.

John Willes (1777–1852): An Innovative Cricketer

Willes was born in Headcorn in 1771 and is credited with introducing round, or over-arm, bowling into cricket. Willes copied the style from his wife, who found when they played together if she bowled conventional underarm, her hooped skirt would get in the way. He introduced the new bowling style during a match on Penenden Heath in 1807 between thirteen Men of England and twenty-three Men of Kent, but it proved extremely unpopular with the opposition and their supporters. He incensed spectators so much that, having made catcalls at him, they made the first ever recorded pitch invasion, uprooting the stumps rather than allowing him to continue with his unconventional style of bowling.

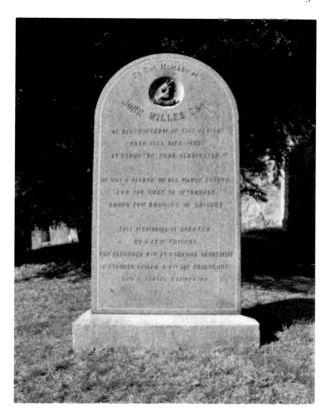

John Willes' grave.

In 1820 the Marylebone Cricket Club implemented a rule that the ball must be bowled underarm and when Willes bowled an over-arm delivery in a game at Lords in 1822, it was declared a 'no ball'. He repeated the delivery, which was also declared a 'no ball'. An outraged Willes threw down the ball, stormed off the pitch in disgust, mounted his horse and rode off, vowing never to play another game. He died in 1852 and is buried in the churchyard of St Mary the Virgin at Sutton Valence. His memorial describes him as a 'patron of all manly sports and the first to introduce round arm bowling to cricket'.

Alfred Mynn (1807–61): The Lion of Kent
Alfred Mynn was born on 19 January 1807 and, having been coached by the legendary John Willes, became a first-class cricketer during the game's round-arm era. A genuine all-rounder, he was both an attacking right-handed batsman and a formidable right-arm fast bowler. John Woodcock, the eminent cricket writer, ranked him as the fourth-greatest cricketer of all time. Journalist Simon Wilde wrote, 'The speed at which Mynn bowled and his life-sized personality captured the imagination of the public in a way no cricketer had before.'

A very large man whose stature was compared with legendary cricketer W. G. Grace, he was over 6 feet tall and weighed more than 21 stones. He earned the title 'The Lion of Kent', for whom he achieved most of his greatest feats, although he also played a considerable

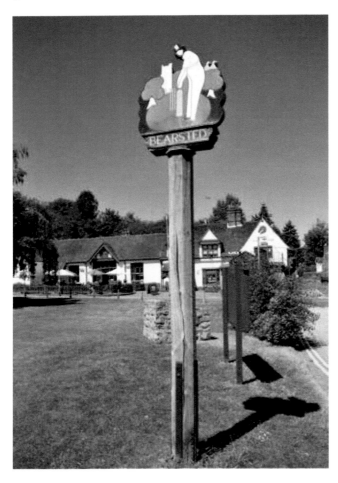

Bearsted Green.

number of matches for Sussex, the Marylebone Cricket Club and the All-England Eleven. He played in 213 first-class matches.

Following a cricketing injury, Mynn experienced financial difficulties. He played as an amateur and as a gentleman risked social disgrace each time he accepted money for playing, although he was frequently saved from his creditors by wealthy patrons who wanted him free to play in matches they had interests in. He was imprisoned several times for debts owed to moneylenders and bankrupted in 1845.

An enthusiastic amateur actor, Mynn regularly appeared for the 'Old Stagers' during Canterbury Week, playing strongmen such as Hercules, and in 1853 the *Kentish Gazette* noted his appearance as 'The Grand German Water Drinker' drinking no less than twelve tumblers of water in six minutes. A diabetic, he died suddenly from his illness in London in 1891. Mynn was a member of the Leeds and Hollingbourne Volunteers and was buried with full military honours at Thurnham Churchyard next to two of his daughters. Mynn is commemorated on the village green at Bearsted where a metal representation of him stands.

5. Defence, Dedication and Devotion

Today only two of Maidstone's castles remain intact – others exist as ruins and earthworks, or have disappeared altogether. Kent's first defences were Iron Age hill forts located on high ground like those found at Oldbury to the west of Maidstone, and Bigbury to the east. However, no evidence has been found of hill forts at strategic locations between them at Detling, Thurnham and Aylesford.

When the Normans arrived they initially built temporary motte-and-bailey castles on the sites of many hill forts as defences against the Saxons whose lands they now controlled. They consisted of the 'motte', a large conical mound of earth or rubble, topped by a wooden palisade surrounding a stone or timber tower, and the bailey, an embanked enclosure containing other buildings joined to the motte.

Located in strategic positions within towns, villages and open countryside, motte-and-bailey castles dominated the landscape. The remains of three former motte-and-bailey castles that once formed part of the valley's defence system can still be seen. At Stockbury only earthworks remain, the motte has been levelled, and only half of the outer ditch is visible, while the ditch of the inner bailey is almost intact. It was originally part of a holding of Bishop Odo of Bayeux, William the Conqueror's

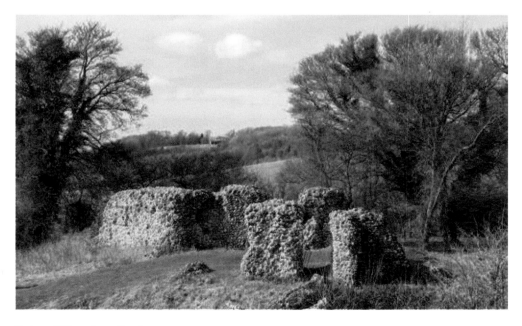

Ruins of Thurnham Castle.

half-brother. It also belonged to Nicholas de Criol, who in 1240 was constable of the Tower of London, and in 1242 Sheriff of Kent and constable of the castles of Dover and Rochester. It fell into ruin following the Wars of the Roses in 1460, and is now part of Church Farm.

Nearby at Binbury are the remains of a walled motte-and-bailey castle. It is a 16-foot-high (5-metre) oval mound surrounded by a large dry moat, and within the bailey are the remnants of its tower. Another example, built by Robert de Thurnham during the reign of Henry II, is nearby at Thurnham. In addition to earthworks, the ruins of the gatehouse with a blocked Norman-style archway, curtain wall and a stone-built shell keep can be seen.

DID YOU KNOW?

Robert Thurnham and his brother Stephen set out from their castle in Kent to join Richard the Lionheart and the rest of Europe's nobility in the Third Crusade.

As the Norman invasion transitioned from conquest to settlement, their style of fortifications changed. Motte-and-bailey structures gave way to large stone castles, which acted as strongholds during offensive and defensive operations. They also provided for the everyday needs of the castle's nobility and were used as centres for local or royal administration. Located strategically and designed to intimidate, they were built as a permanent defence against the Saxons.

In medieval times, the castle at Sutton Valence built upon a motte-and-bailey was a strongly defended site. It stood defiantly upon the hillside occupying the entire spur, its

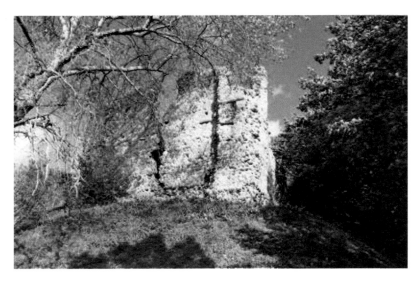

Ruins of Sutton Valence Castle.

presence both dominant and daunting. Built in the middle of the twelfth century by the Norman Count of Aumale, Baldwin de Bethune, it overlooked a strategic route to the coast and was a residence to important lords and earls for over 150 years, changing hands many times through marriage, death and forfeiture. Abandoned in the early fourteenth century, it fell into ruin. Today all that remains are the stone keep that originally stood 60 feet high (20 metres) and a ruined section of curtain wall.

The most iconic of Maidstone's castles is at Leeds. Visited by people from all round the world, the castle is set on two islands in a magnificent lake and is one of the most beautiful in the world. It is steeped in history. In 857 the site was in the middle of the River Len and featured a wooden structure built by the Saxon chief Led. Rebuilt in stone in 1190 by Robert de Crevecoeur, it acted as a Norman stronghold. Over the centuries, it was continually remodelled and during the reign of Edward I was surrounded by a lake. Following its transformation in 1519 by Henry the VIII, it became the primary residence of Catherine of Aragon. In 1419 Queen Joanna of England was imprisoned there for two years, charged with 'compassing the death and destruction of our lord the king in the most treasonable and horrible manner that could be devised'. It was alleged that she hired two magicians to poison her stepson Henry V through sorcery. Elizabeth I was also imprisoned at the castle during Mary Tudor's reign, and it was used as a prison and arsenal during the English Civil War.

On the River Medway, amid beautiful foliage, Allington Castle was built by the Normans between 1135 and 1154 and has a glorious and noble 800-year history, having been home to many famous individuals. The most famous were the noble Wyatt family. Sir Henry Wyatt was treasurer to Henry VIII, while Sir Thomas the Elder was a poet and

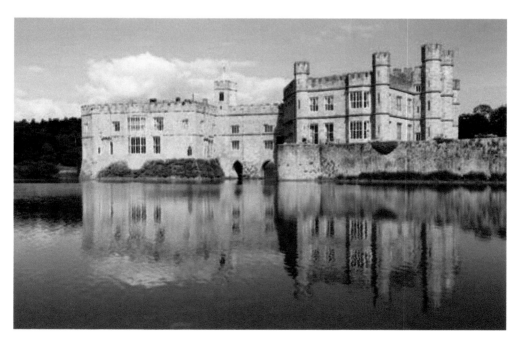

Leeds Castle.

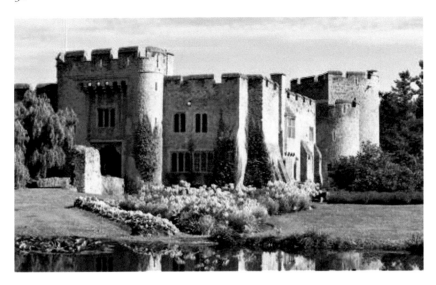

Allington Castle.

courtier and ambassador to Germany, Spain and Holland. He was also the thwarted lover of Anne Boleyn, for which he nearly lost his life. His son, Thomas the Younger, was not so lucky and was executed for leading a rebellion intended to unseat Queen Mary I and replace her with Elizabeth I.

As a result, the Wyatt family lost their title and lands, including Allington Castle. However, when Elizabeth I, a distant relative of the Wyatt family, became queen in 1558, she restored the family titles and lands, leasing the castle to John Astley, a royal courtier. Astley's successors moved from the castle when a fire razed it to the ground in 1600. It remained in ruins until 1905 when explorer Sir Martin Conway began restoring the castle. Changing hands several times, it was eventually purchased as a private residence by Sir Robert Worcester.

DID YOU KNOW?

During the Second World War, Thurnham and Binscombe castles were used as air-raid observation posts and air-raid shelters were built into the historic monuments.

For hundreds of years, the churches of Maidstone have served the spiritual needs of the community. Many are architecturally unique and historically important, while others are connected to influential personalities and historic events. More than just places of worship, churches are boundless repositories of social history and ecclesiastical heritage that for the most part exists unknown and unseen by many, confined to the church and its grounds.

A church has stood by the River Medway in the town since AD 650. The first church was an Anglo-Saxon building, St Mary's, which was torn down in 1395 to make way for All Saints Church. One of the largest and finest examples of Perpendicular architecture in England, All Saints Church houses many family and military memorials and stunning medieval choir stalls. Until 1731, the church possessed a magnificent oak spire covered in lead that rose to a height of 170 feet (52 meters). But, on 2 November, in the early hours of the morning, the town was hit by a fierce electrical storm and the top of the spire was struck by lightning, causing a fire. A large crowd quickly gathered but, despite their numbers and plenty of water, they were unable to stop the flames engulfing the spire. The fire was so intense that it melted the lead, which poured down onto the church roof below and collected in a molten mass. Eventually it seared a hole into the church roof and the melted metal dropped into the nave. By ten o'clock, the fire had burnt itself out without reaching the stonework of the tower. The old lead was collected and sold but the spire was never replaced.

Holy Cross Church at Bearsted is typically Kentish in style. Its most notable feature – the tower – and its parapet date from the middle of the fifteenth century. Unusually, on three corners of the parapet perch stone animals whose identity and purpose were the subject of debate for many years. Today they are thought to represent a lion, a panther and a griffin. Built on the site of an early Saxon church, it was thought no trace of the original church remained. However, during the late 1940s a part of the original Saxon

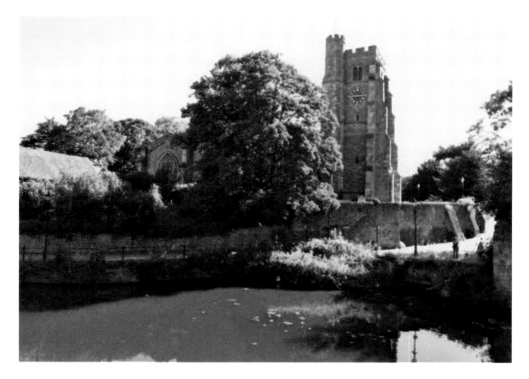

All Saints Church.

arch was discovered at the west end of the nave, on the north side. Below the respond of the arch are two consecration marks, a large painted cross with a smaller incised cross below. Dated to the twelfth century, they are the earliest known consecration crosses in the country. Until their discovery, both the crosses and arch had been hidden since the thirteenth century when the present north aisle replaced the original Saxon aisle.

Britain's last alchemist, Doctor Robert Fludd (1574–1637) is buried within the grounds and remembered inside the church (see Chapter 4). Also buried here is the last man to be publicly hanged at Penenden Heath, John Dyke. Dyke a former soldier, was executed on Christmas Eve 1830 after being accused of setting fire to Otteridge Farm in Yeoman Lane, Bearsted – where the doctors' surgery stands today. He had been visiting his grandparents close to the scene of the fire and was suspected of supporting people involved in the Swing Riots. He maintained his innocence throughout his trial, but was convicted for arson. After the hanging, Dyke was buried in the churchyard where friends and family placed a large boulder on the spot to deter grave robbers. Years later, a man called Hewitt made a deathbed confession that he had set the fire. Today a stone plaque recording the fact Dyke was innocent marks the spot of his grave, and fresh flowers are regularly placed there in a small vase by an unknown visitor.

The church of St Nicholas at Leeds, although small, was well established in Anglo-Saxon times. When the Normans arrived they made major changes, and today it is something of an enigma. The twelfth-century tower is one of the finest examples of its type and the second largest in England – not in height but width – with walls 8 feet thick and buttresses on each corner that appear to serve no architectural purpose. The spire is disproportionately small and dwarfed by the tower. Inside, the tower is one of the earliest surviving bell frames in the United Kingdom. The ancient oak frame holds ten bells: six small bells dated at 1757, three others at 1756, and the biggest and oldest, the tenor, is dated 1617. The bells were made by a prominent Kent bell founder and local resident

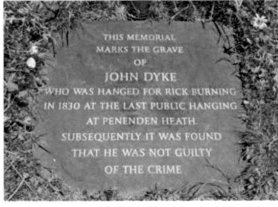

Above: John Dyke burial marker.

Left: Consecration mark, Holly Cross Church.

Joseph Hatch, who cast 155 church bells, including 'Bell Harry', after which the central tower of Canterbury Cathedral is named. The tower and the nave are so big inside that a meeting room has been built within it. The church boasts a most impressive rood screen and a finely carved wooden wall, separating the nave from the chancel, which extends across the entire width of the church and has eleven bays and three entranceways.

Constructed in the twelfth century, the Church of St Martin of Tours at Detling has an unusually grand ancient wooden lectern that swivels on its base and has four reading sides. Dated to 1340, it is one of the oldest examples of its kind in the county. The churchyard's most notable features are two impressive yew trees, whose imposing girths measured 18 feet 6 inches and 18 feet 1 inch in 1999. The branches of the yew tree beside the path from the porch to the gate once obstructed the roadway. Thanks to the generosity of local residents, the road was diverted to protect the tree. The thirteenth-century All Saints Church at Loose boasts an even bigger yew – one of the largest in the country at 2,000 years old, it has a girth of 33 feet.

Described by a journalist in 1923 as a 'veritable wonder', St Mary's in Lenham, with its battlemented tower and small turret, is a quintessential English church. Destroyed by fire in 1297, it has been remodelled several times and has an abundance of furnishings and monuments that bear testimony to its rich history. Its highlights include a mysterious tomb in the vestry of an unknown reclining robed figure and in the chancel is a splendid stone altar, a unique survival from the Elizabethan purge. The fifteenth-century choir

Choir stalls, St Mary's.

stalls with their misericord seats and poppy heads are a rare feature, as is the 500-year-old lectern with its swinging head. On the south wall is a stunning mural of St Michael overseeing the weighing of souls passing to the afterlife.

In addition to some visible masonry marks, the church has several medieval devotion carvings. The double 'V' mark carved as 'W' representing the cult of the Virgin Mary can be clearly seen on the doorframe in the vestry. In fact, almost all the medieval churches within the borough possess contemporary devotion marks of some type – from simple crosses to elaborate interlocking circles. Often overlooked and hidden, these images represent the now lost voices of medieval history, and while their interpretation divides opinion, to find one is always rewarding.

At Ulcombe, within the eleventh-century church of All Saints in the south aisle are two remarkable medieval wall paintings depicting St Michael defeating Satan, a number of crucifixions and Lazarus. While at Harrietsham, St John the Baptist's Church has a twelfth-century carved marble font, described as one of the finest Norman fonts in the country. It seems every church within the borough has a least one fascinating fact, feature or secret waiting to be discovered, or one interesting link to the borough's past, and in some cases more than one. An example is the church of St Peter's and St Pauls at Yalding, where you can see a great oak ball that once rang the church bell during the sixteenth century providing a rare glimpse into the craftsmanship of the time.

Above left: Devotion mark, St Mary's Church.

Above right: Devotion mark, St John the Baptist Church.

Devotion mark, All Saints Church, Ulcombe.

Medieval wall painting, All Saints Church, Ulcombe.

Above: Font at St John the Baptist Church.

Left: Giant Oak Ball, St Peter and St Paul's Church.

6. Gallows, Gaols, Punishment and Policing

Anglo-Saxon England lacked anything that could be described as a police force. People lived in small villages and law enforcement was based around the local community, who knew their neighbours. For minor crimes people either went on trial and were judged by men from the village who formed a jury, or they underwent trial by ordeal in which individuals performed tasks such as carrying a piece of red-hot iron or placing their hand in boiling water. God's judgement of guilt or innocence was reflected in how well their wounds healed and decided their fate.

Over the centuries these methods were faded out and a range of legal methods to deal with minor offences were introduced, such as whipping. In Maidstone, early court records are full of accounts of whippings being used as punishment. In 1697 Mary Willis and Thomas Ward were convicted of stealing linen; their punishment was to be stripped to the waist, tied to the whipping post in the High Street and flogged. The post was removed in the late eighteenth century, after which offenders were tied to one of the old corn market pillars and lashed. Whipping was still in use during the 1800s, and in 1811 an unnamed man, having entered a house and stolen a tea kettle, was ordered to be whipped for 50 yards. In such cases the offender was stripped to the waist, tied to the tailboard of a cart and whipped as he or she walked slowly along the town's High Street, from Diprose's Passage to Rose Yard.

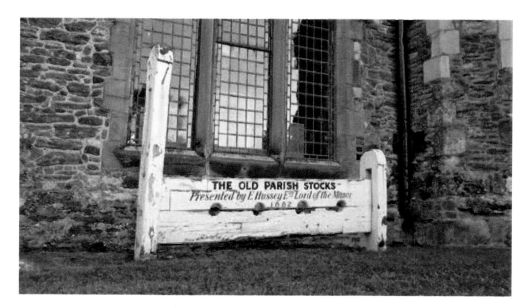

Original stocks at Marden.

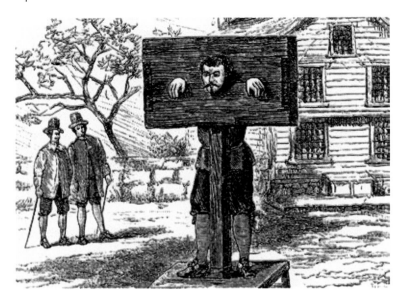

Typical pillory post.

Records of 1697 show five men convicted of felony were sentenced to be branded on the hand. Other methods of public admonishment included the pillory (a wooden framework with holes for the head and hands), in which an offender was imprisoned and exposed for an hour to public abuse and/or pelted with offal and rotten eggs. A permanent pillory that stood at the top of the High Street, near the Market Cross, was dismantled in 1771 by the local authority but retained so it could be set up as needed outside the old Town Hall. The last people pilloried were two men for assisting French prisoners of war to escape during the first decade of the eighteenth century. Stocks were prevalent in villages and stood in various parts of the town. In 1650, two Quakers – John Stubbs and William Caton – were placed in stocks and whipped with cord in a manner described as cruel and bloody.

DID YOU KNOW?

In 1685, having been imprisoned for twenty years at Maidstone for conscientious objections, Baptist pastor and medical practitioner Joseph Wright was released and ordered by James II against his will to become Mayor of Maidstone. A duty he had to perform until the ascendancy of William and Mary in 1689.

Since the earliest times, serious crimes incurred the death penalty and were carried out at a meeting known as the 'Moot gathering'. Held for administrative matters, debating issues and sharing important information, Maidstone's Moot was at Pinian (meaning 'to punish') and is recorded in the Domesday Book as 'Pinnedenna', known today as Penenden Heath.

In addition to showing that justice had been served, death by hanging was intended to deter others from committing crime while reinforcing the importance of being loyal to the king and living good and lawful lives. Hanging was introduced to Britain by the Germanic Anglo-Saxon tribes during the fifth century. William the Conqueror ordered hanging only in cases where royal deer had been poached, but Henry I reintroduced it as a means of execution for a wide range of offences, and by the eighteenth century hanging had become the principle punishment for capital crimes until the mid-twentieth century.

Maidstone's association with public executions is a long and grisly one. Early nineteenth-century maps show Gallows Hill at Penenden Heath as a site of public execution. Early trials were held on the heath and those condemned to die were forced to walk up the hill to their death, where they were hanged from one of three large trees. Today, only one tree remains at the end of a residential garden. Originally, the bodies of convicted criminals were buried away from settlements in unmarked graves, and nearby Gallows Woods is believed to be the location of such a cemetery. Later relatives or friends were allowed to remove the body for a more local burial.

As Maidstone became established, trials took place in the town. The condemned were taken from their place of incarceration on or tied to a hurdle (sled) and conveyed to Gallows Hill along present-day Heathfield Road (originally called Hangman's Lane). Over time, hanging from trees was replaced by hanging from gibbets, single posts with one arm, or gallows, a structure from which several persons could be hanged at once. Gallows were eventually sited on platforms to afford audiences a better view of the spectacle. Death was caused by slow strangulation, often lasting several minutes and resulting in the deceased losing control of their bodily functions. However, people accused of witchcraft or treason were burnt at the stake.

In 1769 Susanna Lott and her lover Benjamin Buss were found guilty of jointly poisoning her husband John Lott. Buss was hanged for murder and his body ordered to be given to the surgeon to be dissected and anatomised. As the law classed murdering your husband as treason, Lott was tied to the back of a hurdle and dragged by a horse to the heath. There, having watched Buss hanged, she was suspended by her neck from a peg driven into a tall stake. Slowly dying, she watched as 200 bundles of wood were piled around her. When she eventually died, the wood was lit and she was burned until her remains were just ashes. Witches were routinely burned on the heath until 1692. During excavation works for the present-day children's play area, a site where burnings took place was discovered.

For acts of high treason other methods of execution were employed, like those endured by Father James Coigly. A brave patriot to some, he was known as the priest of Dundalk, who on 28 February 1798 was staying at the King's Head public house, Margate, when he was arrested for treason. With others he had plotted to cross the Channel to pass information later defined as 'treasonable communications' to the French Revolutionary government. Following his arrest, he was taken to Maidstone, where he was tried, convicted and sentenced to death to be hanged, drawn and quartered. On 7 June he was placed on a hurdle drawn by two horses and escorted to Penenden Heath by a company of the Maidstone Volunteers. At the gallows, he removed an orange and a penknife from his pocket and handed them to an onlooker. He asked the man to cut open the fruit to

The playground at
Penenden Heath.

publicly disprove rumours that he intended to commit suicide. Being a martyr to his cause he said, 'I would not deprive myself of dying in this manner for my country.'

Coigly was hanged by the neck for ten minutes, then cut down. Still alive, his bowels were removed and burnt before his face. Next, his head was severed from his body by a town surgeon and then grabbed by the executioner, who raised it aloft shouting, 'This is the head of a traitor.' The head shook violently, causing him to drop it and flee in terror. Unbeknown and to the disappointment of the ghoulish crowd, George III had earlier remitted the other acts.

DID YOU KNOW?

At early hangings, friends or family would unwillingly pull the accused down to speed up proceedings and end their suffering. Individuals with no friends or family would often pay a stranger to perform this function and they became known as 'Hangers On.' Those who chose not to have their legs pulled were called 'Die Hards.'

In the early 1800s, residents now living on the heath complained about the huge crowds gathering on execution days, creating a great social gathering with boisterous merrymaking, drinking, revelling and fighting day and night. This resulted in a new site being selected for the gallows in 1813 near Faraday Road. Being on low ground with less passing traffic and shielded by the Bull public house, the undersheriff thought this would appease residents.

It did not, and the unhappy locals complained that executions were being treated by workmen and apprentices as a day of pleasure. Executions, they argued, should draw

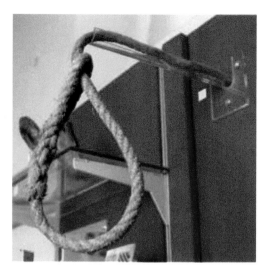

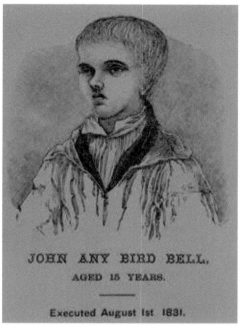

JOHN ANY BIRD BELL.

AGED 15 YEARS.

Executed August 1st 1831.

Above: Noose used to hang John Dyke.

Right: John Bell. (Courtesy of MMBAG)

crowds to deter people and encourage them to live lawful lives, yet it seemed many residents missed this point and were using the event to display shameful and wanton behaviours. The last hanging on the heath was carried out in 1830 by the infamous William Calcraft, the longest serving executioner in British history, credited with executing 450 people. John Dyke, one of three farmworkers found guilty of 'Arson of a barn' was hanged on Christmas Eve and buried in Holy Cross Church, Bearsted.

From 1831, Maidstone Prison became the normal place of execution for those condemned to death in the county of Kent, with executions taking place outside the main gate at noon. The youngest person to be executed at Maidstone was fourteen-year-old John Bell. A crowd of 10,000 watched him hang on 1 August 1831 for the murder of thirteen-year-old Richard Taylor.

On 2 April 1868, Frances Kidder became the last woman to be publicly hanged in Britain, for the murder of her eleven-year-old stepdaughter. A crowd of 2,000 had gathered and while waiting to witness the historic event they threw pennies into the crumpled hats of jugglers, tumblers and masters of magic, while piemen sold pastries. The last man to be hanged in public at Maidstone was Richard Bishop, who was hanged on 30 April 1868 for the murder of his neighbour, Alfred Cartwright.

Parliament passed an amendment to the Capital Punishment Act on 29 May 1868, ending public hangings and directing that executions take place in private within prisons. The first person to be privately hanged in the prison was eighteen-year-old Thomas Wells on 13 August 1868 for shooting his stationmaster employer. While nineteen-year-old Bandsman John Morgan was executed on 30 March 1875 for cutting the throat of a fellow Bandsman and became the first prisoner to benefit from the new 'long drop' method of

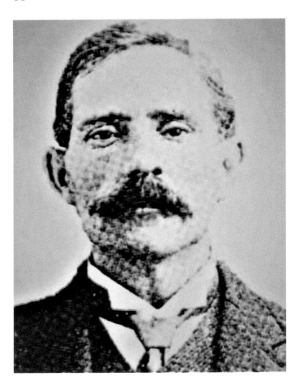

George Smith.

hanging, dying almost instantly. The most notorious criminal to end his days there was 'the Brides in the Bath' murderer, George Joseph Smith, a bigamist and serial killer who married three women then drowned them to claim the insurance. He was hanged on 13 August 1915.

The last execution at Maidstone Prison was on 8 April 1930 when thirty-one-year-old Sidney Fox was hanged for the murder of his mother, Rosaline. Following Fox's hanging, prisoners condemned to death in Kent were executed at Wandsworth Prison, London. In all, fifty-eight executions took place at Maidstone Prison – twenty-eight in public and thirty within the walls of the prison.

The first gaol in Maidstone was in the Archbishop's Palace. Gaols were used to hold prisoners awaiting trial, execution and exile by transportation to Australia. Before penal servitude was introduced in 1853, detention was a temporary measure and only debtors were kept in prison for any length of time. Bridewells established under the Elizabethan Poor Law Acts were houses of correction for the vagrant poor and were essentially criminal workhouses where paupers were imprisoned for long periods.

There were three prisons in Maidstone: the town and county prisons were in the High Street, with the third – 'The Dungeon' – in the Archbishop's Palace where John Ball, the 'Mad Priest', a roving, radical minister who preached in rhyme, was incarcerated. During the reign of Queen Mary, her 'Marian Prosecutions' inflicted death, torture and terror upon Protestants persecuted for their beliefs. In 1557, two men and five women convicted of heresy were held and tortured in the town prison before being burnt alive at the stake at Fairmeadow, now the site of the Cork and Casket public house. Twenty-seven years

Archbishop's
Gaol.

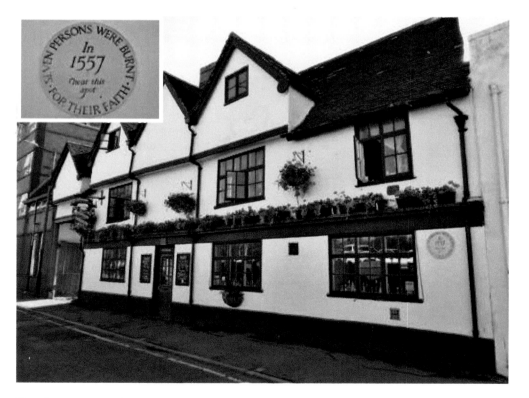

Site of martyr executions.

Inset: Plaque to the martyrs.

Graffiti on the Town
Hall Gaol.

earlier at Maidstone on 23 February, Thomas Hitton became the first English Protestant
martyr of the Reformation to be burnt at the stake for heresy on the site where the
Russian cannon now stands.

Separate debtors' and felons' gaols were introduced during the 1700s. Maidstone's
first county prison was situated in the High Street between Rose Yard and Week Street.
Prisoners spent their time spinning wool in silence. Solitary confinement in a dark cell
was the punishment for offences committed within the prison until a treadmill was
introduced in 1824.

In 1746 a new prison was built in East Lane (present-day King Street) beside a bridewell
that had been built in 1724 with separate wings for debtors and felons. Although
considered a creditable institution of the day, its proximity to the street encouraged
outsiders to pass drink and tools to prisoners, resulting in several daring prison breakouts.
In January 1776, a highwayman called Giles, and several other felons, attempted an
escape from the Felons' Gaol while taking exercise in the courtyard. Before order could be
restored, the keeper of the keys was obliged to fire upon them, wounding Giles in the leg.
Giles was later convicted of highway robbery and executed.

A plot by twelve prisoners to escape in July 1786 was foiled by a vigilant turnkey (prison
officer), but two years later, in September 1788, James Tyler, helped by other prisoners,
cut away part of the frame from an upper window. While Tyler was climbing down a
makeshift rope into the street he was attacked by a furious dog, which terrified him so
badly that he gave up on his descent; the barking alarmed the prison keeper, who entered
the cell and secured Tyler.

The county prison was replaced in 1819 with a new prison in County Road, which is still used today. With a wall over a mile in length, it has housed some of Britain's most dangerous criminals including London gangster Reggie Kray and Bruce 'Napoleon' Reynolds, leader of the Great Train Robbery gang. During the eighteenth century other buildings, such as workhouse mortuaries, doubled up as 'lock-ups' for minor offences, an example of which can be seen at Lenham.

Above: Maidstone County Prison today.

Right: Bruce Reynolds.

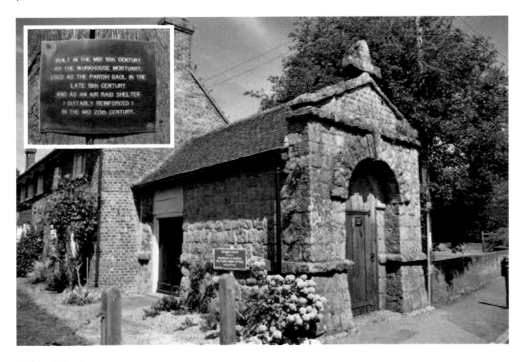

Old gaol, Lenham.

By 1835 the need to unify the law enforcement system was recognised and Parliament extended Sir Robert Peel's system of policing to towns and boroughs, and eventually to counties. The original Maidstone Borough Police Force, formed in 1836, lasted for 107 years. Originally located in King Street, opposite Church Street, it moved in 1908 to larger premises in Palace Avenue. In 1856 the government legislated that each county must have its own constabulary in addition to borough forces, and Kent County Constabulary was created. Its headquarters were located at Wrens Cross, a house on the junction of Stone Street, Mote Road and Knightrider Street. In January 1857 former Kings Own Rifle's officer Captain John Ruxton, who had twice overseen convict ships to Australia, became chief constable.

Life was harsh for the 'bobby on the beat' and up until end of nineteenth century they worked a seven-day week with one rest day every two weeks, a hurried snack was their only break, and for reasons of dignity they were instructed to eat their sandwiches within a public convenience.

One of the tasks of the county force was the suppression of illegal prize fights, which took place beside the rail tracks and with the full support of rail company directors, who would lay on special trains to convey spectators to the events. In 1859, a train carrying over 2,000 spectators from London stopped just outside Headcorn, where a ring had been set up in a field and prize fighting took place without the police knowing. Captain Ruxton remained the chief constable for thirty-seven years before retiring aged seventy-seven – out serving every original member of the force.

Early police officer.
(Courtesy of KPM)

The county force's headquarters moved to Sutton Road in 1936, and in 1943, along with other borough forces in Kent, Maidstone Borough Force was compelled to merge into the County Police Force. At the time of the merger, some boroughs employed female officers, and this became the first time that police women served in the county force.

DID YOU KNOW?

In 1884, the purchase of four caps and gabardines for use as disguises to deploy plain clothes officers was authorised. This was one of the first instances of undercover policing in the country.

7. Bears, Bombs and Bones

Maidstone is rich in virtually unknown, forgotten and sometimes completely hidden treasures, all of them gems just waiting to be discovered. This chapter presents an odd assortment of those treasures whose gifts did not quite fit with previous chapters.

Founded by Maidstone's Sir Garrard Tyrwhitt-Drake at Cobtree Park, Kent Zoo Park's opening ceremony took place on 29 March 1934. It was opened by renowned circus owner Bertram Mills and featured, among other exotic animals, lions, elephants and polar bears. Described as an extravaganza, the opening ceremony set the benchmark for future reopenings. The zoo housed the country's largest collection of privately owned animals and was the county's biggest tourist attraction. In 1939, it became Maidstone Zoo Park with the seasonal reopening programme for that year listing thirty-six species of animals including bears, camels, cheetahs, chimpanzees, deer, elephants, kangaroos, lions, llamas, yaks, zebras and wolves. As well as many types of birds, fish and reptiles, there was a stud of cream ponies – one of only two in the country.

The Elephant House, Cobtree Park.

Over the decade's, successive reopenings and christenings of the larger animals at the zoo attracted stars of stage, screen and radio. Among them were film stars Gracie Fields, Stanley Holloway, John Mills, Mary Hayley Bell, Julie Andrews, Lisa Daniely, singer Petula Clark, music conductor Sir Malcolm Sargent and broadcaster Richard Dimbleby. A personality who rarely missed an opening was Maidstone's own local celebrity, Richard Hearn. Hearn was the first performer to be known as a 'television star' and to have his own television series, in which he played a bumbling old man called 'Mr Pastry'. Following the official opening, Hearn would disappear and reappear as Mr Pastry to entertain children and adults with his slapstick tomfoolery. The zoo also received royal visits from Princess Elizabeth in 1946 and the Duke and Duchess of Gloucester in 1951 and 1959.

In 1937, a large model village was added, and Avery Brothers of Maidstone built a petrol-powered steam engine locomotive with two carriages for the zoo's miniature railway, which ran 1,640 feet (500 metres) from the Maidstone–Rochester road to the zoo's entrance. In the coming years an aquarium, giant aviary, sea lion, penguin and polar bear pools and dog track were added.

Life at the zoo was not without perils and adventures. Soon after opening, sixteen-year-old assistant Frederick Cashford was trying to remove debris from the cage of a black Himalayan bear when it attacked him. On hearing the screams, staff rushed to his aid to find him outside the cage being held by the bear who had clamped onto his right arm and was trying to pull him into the cage. The bear was eventually forced to release Cashford, who was rushed to hospital with a mauled right arm and left hand, which he had used to prise the bear's jaws open. His injuries resulted in his right arm being amputated above the elbow. Although the operation was a success, septicaemia set in and he died from a heart attack. The death increased numbers of visitors whose morbid curiosity had drawn them to see the killer bear first-hand.

Despite the outbreak of war in 1939, the zoo remained open. Food shortages led to the cream ponies being slaughtered to feed the meat eaters, and the public donated food not fit for human consumption. The zoo's aviary was bombed in 1941, creating a huge crater, and in September 1944, although no one was injured, a Doodlebug fell on the zoo, blowing the roof off the gatehouse.

The zoo continued to expand and by 1949 it covered 10 acres with 150 cages. Wolves and foxes were kept in woodland, a pet's corner housed small animals for children to handle, and elephant and pony rides were a regular attraction. Its own rare breeding programme produced the country's first 'zebroid' – zebra/ass cross. However, the 'tigon' – tiger/lion – experiment was unsuccessful. The zoo closed in 1959 because of rising costs and today the site has been transformed into a park and golf course. Off the beaten track and known only to a few are the remains of the Garrard's family pet cemetery, containing the graves of many of their cats and dogs.

During the Second World War, Maidstone was attacked by V-1 flying bombs and V-2 rockets, but it was also attacked several times by Hitler's V-3 'Supergun'. The first of these reports came on 20 November 1940, when two sudden and unexplained explosions occurred near Bearsted. No enemy aircraft had been reported in the area and the source of the explosion was unknown. However, when splinters were examined they were found to have come from German 12-inch shells. The only German weapon capable of

Pet Cemetery, Cobtree Park.

reaching Maidstone from France was the K12 railway gun, operated by an artillery battery stationed 53 miles away at Cape Gris-Nez, Pas-de-Calais, France. During the war, they only fired eighty-three shots at England and while several other areas in Kent were struck, Maidstone was never shelled again by the railway gun.

However, on 13 June 1944 between 0030 and 0400 hours, the town was again struck by a series of explosions. At Hayle Place, Tovil, one woman was killed, and at Otham and Bearsted considerable damage was caused. A German Flak Regiment at Mimoyecques, France, had fired eight test shells from the V-3 Supergun as a distraction from the first launching of the new V-1 rockets later that day. In response, the RAF led a 106 Halifax bomber raid on Mimoyecques, where their bombs destroyed the site and neutralised the threat of the V-3 to Britain.

During the Cold War, the threat of nuclear attack resulted in thousands of secret government bunkers being built around the UK to protect key political and military leaders, as well as prominent scientific, medical figures and other important personnel. Other bunkers were built for members of the Royal Observer Corps, whose role was to monitor the impact and effects of an attack and coordinate appropriate responses.

The Kent County Council's headquarters complex was located within a bunker at the Springfield County Council buildings and was a single-storey shelter built under the staff canteen. It was designed to accommodate communications and different departments of the county council as well as police and military liaison officers. The bunker was used by staff for training and paper exercises during the 1970s and 1980s.

Several Royal Observer Corps (ROC) monitoring posts were built across the borough. The Bearsted and Lenham bunkers have since been demolished, but at Maidstone an

K12 Railway Gun.

underground headquarters bunker has survived and, although recently open to the public, is shrouded in secrecy. Located at Ashmore House, No. 57 London Road, the property was originally requisitioned in 1939 by the ROC as a new headquarters for No. 1 Group ROC, who had previously been stationed in rooms above the Maidstone Post Office. An operations room was built in the house using the ground floor and basement and in 1960 a bunker was built at the rear of the site. When it closed in the early 1990s, Ashmore House and the bunker were sold to a local solicitor.

Over the centuries, plague and epidemics brought tragedy to the town. The Black Death visited eight times between 1349 and 1668, and smallpox twelve times between 1602 and 1826, with each case lasting many months. Influenza arrived in the late 1550s, while outbreaks of cholera, scarlet fever and diphtheria abounded during the 1890s.

However, it was the town's water supply that carried the most devastating disease to visit the town. Originally, water was conveyed in pipes across the Medway to conduits in the town. The first was built in 1567 in the centre of the High Street, an octagonal tower, 24 feet (7 metres) high and 8 feet (2.5 metres) in diameter with an internal winding stairway that led to a dome containing a clock, lantern and bell. The second, a large tomb-shaped design built in 1625, was at the bottom of the High Street, and in 1645 a third was at the top of this thoroughfare.

When the town was paved, drained and lit between 1792 and 1794, the original conduit causing an obstruction was removed; its clock and lantern were transferred to the present Town Hall. The one at the bottom of the High Street was moved to Brenchley Gardens, and in 1819 the pipes were replaced with new iron ones that serviced seventeen public conduits in the lowest parts of the town.

Above: Royal Observer Corps Observation Post.

Left: Conduit, Maidstone High Street, 1786. (Courtesy of MMBAG)

Water conduit, Brenchley Gardens.

In 1851, the conduit water was not pumped directly to houses, the Corporation provided public handpumps and seventy-five private wells were sunk, but they all too frequently ran dry. To meet the demand of an expanding town, in 1892 a steam-operated pumping station was constructed at Aylesford to supplement the output from the original Farleigh pumping station. However, in mid-August 1897 the town suffered a severe setback when an outbreak of typhoid fever raged through the borough creating a national panic. By September, there were 117 cases and by December the number of cases totalled 1,847 with 132 deaths.

The epidemic was caused by polluted water from the Maidstone Water Company at its Farleigh works. An inspection found grave sanitary defects in the construction of some sewers, house drains and water closets within the borough. As a result, significant breakthroughs were made in modern sanitation, public health practices, and national improvements in water and sewage management were undertaken. The town itself was left with an everlasting reminder of the courage and dedication of those who came to help its stricken residents.

To contain the disease, volunteers were needed to help care for the sick. Among the dozens who arrived, over twenty trained nurses were from the London Hospital. Among them was a twenty-two-year-old probationary nurse Edith Cavell, who worked mainly night shifts during the epidemic caring for children.

With the epidemic successfully overcome, Edith was awarded the Maidstone Typhoid Medal for her services, along with 259 others who had displayed courage and devotion.

Typhoid victims, Sutton Road Cemetery. (Courtesy of Sarah Rogers)

She returned to the Royal London Hospital to complete her training, but her heroism didn't end there. During the First World War, Edith became matron of a training school in Belgium caring for soldiers from both sides. She smuggled many British and Allied soldiers to safety, but was caught by German forces, convicted of treason and executed by firing squad on 12 October 1915. On the wall of the United Reformed Church in Week Street, where Edith was awarded her medal, is a plaque to her memory.

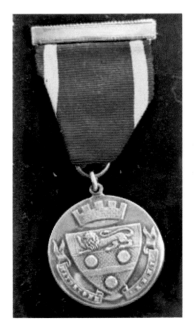

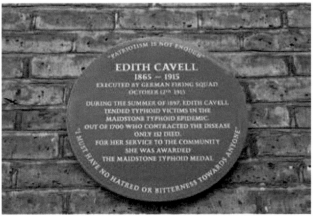

Above: Edith Cavell plaque.

Left: Typhoid Medal. (Courtesy of Sarah Rogers)

DID YOU KNOW?

Near to Edith Cavell's memorial in Week Street is a historic treasure, a pillar box that thousands of people pass by each day without noticing. Most of the town's post boxes are stamped 'EIIR' for Elizabeth the Second Regina. This one is stamped 'EVIIIR' for Edward VIII, who was king for only 326 days, abdicating in 1936 to marry Mrs Wallis Simpson. Only 161 pillar boxes stamped with his initials were made, and this is the only one to survive in Maidstone; the only other to survive is in Kent at Ramsgate.

Also in Week Street, beside No. 22, is a through-passage giving access from the street to the rear yard. Behind the gate, out of sight but accessible, is a Victorian water pump, a vestige of days gone by and a unique piece of the town's heritage.

The town has many literary links. Samuel Pepys visited and stayed in the town and Charles Dickens knew the Medway towns well and visited Maidstone many times, referring to it as 'Muggleton' in his famous novel *The Pickwick Papers*. Dickens describes Muggleton as a corporate town with a gaol and tells an entertaining tale of Kent's first cricket match taking place at Penenden Heath between All Muggleton and Dingley Dell (Cobtree), although the residents of nearby West Malling claim the match took place there, at Norman Road, in 1705.

Victorian water pump.

However, Charles Dickens's most memorable visit to the borough was on 9 July 1865, when he was a passenger aboard a train returning home from Paris that derailed on a bridge over the River Beult between Staplehurst and Headcorn. The accident happened after a ganger in charge of line maintenance failed to stop the Folkestone to London express. Following the crash, Dickens who'd been travelling in the first of the derailed coaches, climbed out of a window and rescued two ladies before returning to help the wounded and the dying. He recorded the incident stating, 'I came across a man, covered in blood ... with such a frightful cut across his skull that I couldn't bear to look at him. I poured some water over his face and gave him some to drink, then gave him some brandy, and laid him down on the grass, and he said, 'I am gone!' and died soon afterwards.'

The experience severely shocked him, and he never fully recovered. Upon his death on 9 July 1870, friends quickly drew attention to the fact he had died five years to the day after the crash. Today the Muggleton Inn, at Nos 8 and 9 High Street, stands as a reminder to Dickens's association with Maidstone.

The town's oldest and perhaps least-known resident is a 125-million-year-old, 3.5-tonne, 40-foot-long iguanodon called Iggy. Discovered in 1834 in a quarry in Queen's Road, Iggy is the first dinosaur anywhere in the world to appear on a coat of arms. A cast of Iggy's bones was made and is now displayed at Maidstone Museum.

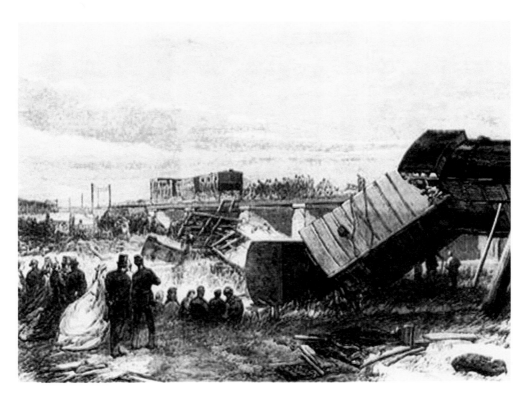

Dickens's rail crash.

Above: The Muggleton Inn.

Right: Iggy on the Maidstone coat of arms.

Also on display at Maidstone Museum is the town's second oldest resident and the only adult human mummy in Kent. The 2,700-year-old Ta-Kush, who arrived in England during the 1820s and forms part of the museum's Egyptian collection.

In 1843, Dr Hugh Welch Diamond, house surgeon at the West Kent Infirmary in Maidstone, and eminent Egyptologist, Samuel Birch of the British Museum, unwrapped and studied Ta-Kush. Dr Diamond eventually presented Ta-Kush to his cousin, Dr Thomas Charles, a gentleman and antiquarian, for his collection. During the 1840s Ta-Kush went on tour and was placed on display at various locations around Maidstone including the Star Hotel. It was during this tour that her head became detached from her body.

Following Charles's death in 1855, he left his collections of art and antiquities to Maidstone Borough Council for preservation. In accordance with his will, the council purchased his home, Chillington Manor, and in 1858 the manor was opened as the Charles Museum, one of the UK's first local authority-run museums.

Although the mummified remains of Ta-Kush have continued to amaze visitors, it wasn't until July 2016 that visitors finally saw what she looked like alive. Following a grant from the Heritage Lottery Fund, a CT scan and facial reconstruction of her remains were undertaken. Originally thought to be fourteen years old, Ta-Kush was more accurately aged as being in her early forties. The scan revealed that she suffered

Mummified Ta-Kush. (Courtesy of MMBAG)

from abscesses in the jaw and a spinal injury, which had compressed two vertebrae together. The scan enabled an image and 3-D bust to be created of how she probably looked, and these are now on display. When the mummified remains of a 2,300-year-old hawk preserved in a tiny sarcophagus were examined as part of the same project, it showed the mummy to be a miscarried twenty-week-old foetus, making it one the world's youngest mummies.

One of the museums best-kept secrets is its hidden door, which once allowed access from the ground floor to the first floor of the original fourteenth-century medieval house of Chillington Manor. The original house only had a ground floor. When a first floor was added an external staircase was built, with the doors at each end opening into the main rooms.

During the 1560s a new manor house was built and the original manor was used as a warehouse. In the 1870s it was demolished, leaving the base of the external staircase and

Edward VIII pillar box.

Former air mail pillar box.

DID YOU KNOW?

At Barming stands a pillar box originally painted Royal Air Force blue that was used to collect mail for the new Air Mail Service introduced in 1930. Today the box is red and the only clues to its original purpose are the chipped paintwork revealing the blue paint beneath, the double plate on the front that originally showed collection times on one side and air mail postage rates on the other, and the words 'Air Mail Only' that are engraved on the box.

the original first-floor door. A stone chapel was erected in its place as a folly, and a new staircase built to provide external access to an observatory, at which time the door was covered over with plasterboard. When display casing in the gallery that had been there for at least thirty-five years was removed, the door was rediscovered. Now covered up behind new display cases, it is unlikely to reappear again for many years.

8. Mysteries, Manifestations and Other Curiosities

Some people scoff at the mention of ghosts, UFOs, big cats, the fairy folk and other paranormal activities. Others are sceptical of supernatural occurrences, folklore and legends. Yet, Maidstone's history is intertwined with tales of witchcraft, demonic possession, curses, strange happenings, mysterious lights, eerie manifestations and paranormal experiences.

In 2012, the Maidstone Area Archaeological Group discovered a 2,000-year-old lead scroll identified as a curse tablet at East Farleigh during an excavation of a Roman farmstead off Lower Road. The tablet, measuring approximately 2 by 4 inches (5 x 10 cm), carries the names of fourteen people written backwards and upside down – an enchantment intended to make life difficult or perverse for the cursed. The Romans used curse tablets to cast spells on people accused of theft and other transgressions; they were rolled up to conceal their inscriptions and then hidden in places considered close to the underworld, such as graves, springs or wells. It is believed the cursed and their cursers lived at East Farleigh.

Churches and cemeteries are often associated with mysterious occurrences and paranormal curiosities. At Ulcombe in 1985, workers restoring All Saints Church thought their activities had invoked the wrath of God, or worse, freed a trapped demonic power. As digging began around the ragstone walls of the church the weather was fine with no sign of rain or dark clouds. As the first shovel broke the soil, fragments of human bones were uncovered. A massive flash of lightning ripped across the sky accompanied by several deafening claps of thunder and a burst of heavy rain. Work was suspended. The incident created uneasiness among those involved; rumour and speculation spread through the village. Tales of lore emerged that cast doubt on the need to continue the work and the dire consequences that might follow for those involved and for the village. Following a lengthy debate, the decision was taken to continue and reluctantly the workers recommenced their digging. They discovered hundreds of human bones, boars' teeth, funerary remains, offerings and other assorted pagan relics. It seems that the church had been built on a pre-Christian burial site and that the disturbed remains were ancient graves.

Propped against the wall of the Church of St Nicholas, Boughton Malherbe is an old headstone. Its original inscription, now weathered, is mostly unreadable, apart from the name 'Tom Baker' and an unfinished date of '1934–'. While the origin of the headstone is unknown, both inscription and headstone predate 1934. It has been in its current, unusual position for as long as anyone can remember and remains a mystery. A mystery that became more curious when the famous *Doctor Who* actor Tom Baker, born in 1934, moved to Boughton Malherbe. There are rumours that when he found out about the headstone, he bought it in advance of his own death.

Tom Baker's headstone.

Another more disturbing mystery involving a headstone occurred in 2010 when the lake in Moat Park was drained for cleaning. During the operation, Councillor Tony Harwood was standing quite some way out on an exposed part of the lake bed when he found half a large tombstone engraved with the words 'born 1813'. Given the nature and location of the find, it raises many unanswered questions about its owner and how and why it came to be in the lake.

Over the centuries, creatures of all shapes and sizes have plagued and terrorised the borough's inhabitants. Comets were once viewed as portents of doom, and in 1869 one passing close to Earth was blamed for worldwide insect invasions, including two that visited the town during July and August. An infestation of aphids occurred that was so dense it created a fog that darkened the skies and shut off sunlight for several days. This was followed by an invasion of ladybirds so great that teams of men were employed to brush them into the sewers.

In 1205 the English chronicler Ralph of Coggeshall wrote that 'horrendous thunder was heard throughout all the night and terrific lightening, being driven forth incessantly from clouds was seen throughout all England. At Maidstone a black cadaver was reported that possessed the head of an ass, the body of a man and other portentous members'.

In 1568, a woman gave birth to a child during an electrical storm, described as having the form and shape of a monstrous beast. The storm raged for two days and two nights, during which the beast terrorised locals, confining them to their homes before it mysteriously disappeared with the storm.

The beast of Blue Bell Hill is a legend that has existed since the sixteenth century when a mysterious creature with pointed ears was seen in Boxley and Burham. Described as a 'Great Dog' it purportedly attacked, killed and ate a rambler. Since then, frequent reports of large cats have been made across the borough, most recently on 19 June 2018, when a woman reported seeing a black leopard at Hollingbourne, while walking her dog. On 5 August 2009, a sheep was killed in local woodland outside the town. Its internal organs had been removed and the stomach contents abandoned several yards away. The flesh of the carcass had been devoured in such a way that the owner stated that in forty years of living in the woods, he had never seen the like. In 2011 at Lenham, more evidence of big cat activity was experienced. A pregnant ewe was found next to a trail of fleece, suggesting a large animal with sharp claws had attacked it from behind. Apart from the lamb's belly being neatly eaten away, and the ewe removed, there were no other injuries to the sheep.

DID YOU KNOW?

The Owl Man of Maidstone, similar in appearance to the American Moth Man, was spotted several times during an outbreak of UFO sightings in the early 1960s. Blue Bell Hill, synonymous with ghostly apparitions, has also been the scene for other paranormal activity. In 1974 witnesses saw a large hairy, Bigfoot-type creature, around 7-feet tall. And in 1991 a glowing-eyed man-beast was seen in the woods of the village, followed in 1997 by a sighting of a creature resembling a large upright gorilla.

Most reported mysteries are paranormal, and hostelries are frequent sources of such activity. At Lenham, the Red Lion pub, previously a coaching inn, is home to a small boy, a monk, and a murdered chambermaid called Alice. Alice Millar was killed by her enraged lover and regularly appears as a full-bodied apparition in the kitchen and rooms 5, 6 and 10. Sightings of a hooded monk – possibly a pilgrim on route to Canterbury – wandering the corridors during the early hours of the morning are common as are reports of an apparition of a small boy in the former banquet room. The Harrow Inn, also in Lenham, has the ghost of a seventeenth-century smuggler, which has been seen and heard in the early hours of the morning singing melodically. Lenham was the main smuggling centre used by the Seasalter Gang, who took over several pubs and farmhouses in the area to store their contraband. Smugglers occasionally fought over the spoils, and it was during one such disagreement that the spirit lost his life and became trapped here as a phantom forever.

A classic tale of a double haunting centres on the King's Head, Grafty Green. During the eighteenth century a smuggler named Dover Bill planned to attack a coach near the pub and rob the passengers. He caused the coach to overturn, decapitating the driver

and killing the passengers. Their bodies were brought to the King's Head where their spirits took up ghostly residence. Hated by all who knew him for his part in the accident, he was barred from the pub and eventually died in poverty. It is reputed that his ghost regularly appears outside the pub and on misty nights, an apparition of a coach driven by a headless coachman sometimes appears. On the pub's front wall are two large signs portraying Dover Bill and a headless coach driver, driving by moonlight.

In the town's Queen Anne pub, glasses mysteriously fall off the shelves and the ghost of a woman believed to have been killed by a cart in the street outside is regularly observed walking through the front doors of the pub only to disappear. On the other side of town at the White Rabbit, the ghost of a young Victorian girl has been seen wandering the corridors and inside room 8 searching for her cat. The disembodied voice of a young girl has also been heard calling for something and she is believed responsible for the door of room 8 opening on its own, moving the chalkboard menus and turning the lights on and off.

The spirit of a Parliamentarian soldier from the Civil War era is said to haunt the Fisherman's Arms. Injured in a skirmish during the Battle of Maidstone, Black Jack, as he is known, stumbled into the building and later died from his wounds. He has been spotted by several managers and locals in the bar area. A half-submerged Civil War Cavalier haunts the upstairs in the towns Ye Old Thirsty Pig and a young girl haunts downstairs; footsteps are heard, and heat is felt from an unused fireplace.

The Kings Head.

Dover Bill.

The Queen Anne.

The stairs leading to the attic at the Dog and Gun are the site of a haunting by an elderly lady who has attempted to push people down them, while at the Bower Inn, the spirit of a man called Sidney, seen standing at the end of the bar, is believed responsible for the taps mysteriously being turned off. At the Cock Inn Boughton Monchelsea, the resident ghost is 'George', who having hanged himself in the Inn now spends the nights being a noisy nuisance, knocking chairs over and throwing wine bottles around the cellar.

Blue Bell Hill is famous for its ghost of a young lady killed in 1965 on the eve of her wedding. On 20 September 1985 at 11.30 p.m., lorry driver Peter Russell was convinced he had run over a woman lying in Hunton Hill Road at Coxheath. A police officer and a doctor arrived at the scene and reassured him that he had not killed the woman and that he should go home. He later attended the police station to enquire after the woman only to be informed there was no record of the incident. Following enquiries, the police concluded the driver had been the victim of a cruel hoax. The mystery has never been solved.

The Museum of Kent Life is the most haunted museum in the county and is home to several apparitions, including a German fighter pilot who crashed on the site, a farmer's wife who died in a cart accident in 1912 and now spends her time looking for her newborn baby, and a ghostly figure wandering by the pond. The Oast House, one of the most haunted buildings in England, is reputedly frequented by cockney hop-pickers, displaced monks from Boxley Abbey and the ghost of Peg Leg Jack.

The town's museum has experienced paranormal activity possibly linked to one of the Civil War's most violent clashes, the Battle of Maidstone, which ended in the old grounds of the museum in what is now Brenchley Gardens. Officially, the museum is not haunted but staff and diners at the museum's café have heard rapping coming from under the floor and a voice repeatedly saying 'Pyewacket', the name of a witch's familiar made famous during the Civil War by Witchfinder General Matthew Hopkins in 1644. Unexplained electrical problems have occurred, crockery has been seen to move unaided and parts of the cafe's furniture has been rearranged. One customer reported suddenly feeling ice cold in the room and when a sceptical staff member said 'Pyewacket' a packet of crisps attached to a stand fell off.

Fairies, mythical beings with magical powers, often appear in folk lore. On four consecutive evenings during August 2017, at a copse on the outskirts of the town near Detling, small mysterious multicoloured balls of light were observed by three witnesses darting among the trees for well over an hour. Following the sightings, the witnesses visited the location and discovered twelve small wooden doors built into trees and stumps. That night the lights stopped appearing, and when they returned the following day to photograph the doors they had vanished.

Mysterious lights and strange objects have also been observed in the skies above Maidstone for over seven decades. While many unidentified flying objects have a logical explanation, either man-made or natural in origin, some sightings remain puzzling. Of the many unusual sightings reported by credible witnesses, the following account observed in November 2017 remains a mystery. The witness and his friend, both military veterans, were crossing an open field at around 8.30 p.m. on their way to the local pub in Otham when their attention was drawn by a high-pitched humming sound coming

from the nearby woods. The sound lasted for about five minutes and then stopped before they could locate it. They carried on walking and after a short distance they heard a low humming sound and saw, rising above the tree line of the woods, three black triangular objects each the size of a large lorry. All three objects were moving slowly in unison but independently, east to west, and each had blue pulsating lights along the front of the triangle with a double set of white static lights underneath. The men watched as the craft performed various manoeuvres for about ten minutes before coming together to form one solid triangle. One witness tried to take pictures on his phone but the fully charged battery had drained.

As the men watched, the triangle, moving in a circular direction above the woods at a height of between 200 and 300 feet (60–90 metres) tilted backwards with the tip of the triangle facing towards the sky and shot upwards disappearing in a couple of seconds. The witnesses, excited and shaken by what they had seen, returned home where they made independent written records and drawings of their experience.

The mysterious 'Lady of the Woods' is a beautifully carved 9-foot oak statue of a pregnant woman with halo-like hair and no facial features. Her hands clasped in prayer, almost Madonna-like, she resides in woodland in Otterden. Her origins are unknown and speculation is rife about who carved her and why. Nobody knows for sure. Situated by a public footpath at Kite Hill that passes an old abandoned and overgrown railway, she's difficult to find. Adorned with necklaces and other decorations, an assortment of offerings is often left at the statue's feet including shells, buttons and other trinkets, suggesting it holds significance for someone or a group and is being venerated or is the focal point of some unknown pilgrimage. Perhaps she is a modern-day goddess figure for today's pagans and spiritualists. However, the most asked question is who is the lady in the woods?

Legend has it she was carved by an Eastern European soldier stationed at the Tank Regiment at Otterden Place during the Second World War, perhaps depicting a loved one back home. Another tells the tale of a student who in the 1970s possessed a gift for carving wood and having chanced upon a fallen oak tree just inside the wood undertook the carving undetected and unimpeded. Or perhaps someone or something else created it and placed it there and its true meaning is waiting to be revealed. Whatever her origins, the lady in the wood is a mysterious and wonderful enigma and the unknown nature of her identity and creator only adds to the intrigue, enhancing the legend of this little-known mystery.

Another story that persists concerns Maidstone's treacle mine. According to an early legend, treacle had been mined in the area now known today as Tovil since the seventeenth century. Its origin goes back much further owing to a twist of nature in the primeval forests that once covered this area. A giant variant of sugar beet existed, which created a sticky layer several miles deep which in time was covered by thick silt deposits from the Loose stream. Compressed during the Ice Age, the layer hardened into treacle ore. First discovered by the Romans who mined it trading treacle ore for gold, silver and other precious metals. The value of the treacle ore and the fame of the mine caused Hengist and Horsa to lead the Angle, Saxon and Jute invasion into Kent and was one of the main reasons they remained.

Lady of the Woods.

Entrance to Tovil Treacle Mine.

In the summer of 1939, as war threatened Europe, the people of Tovil were preoccupied with a more imminent disaster, the closure of the mine. Due to dangerous working conditions, the National Union of Treaclers, called a strike and threatened to close the mine. Four months of negotiations led to improved working conditions and the miners being issued with 'syrups', a form of head protection. Mining continued at the site until the mid-1950s, supplying treacle and liquorice to most of Kent's sweet manufacturers, but the treacle seam ran dry.

The mine was so vast that many of its tunnels extended under the town, with some being used to transport treacle to the Trebor Sharp sweet factory to avoid it being stolen in transit. Following heavy downpours, large sinkholes occasionally appear in the town revealing their existence. Although now blocked up, the entrance is visible, and locals are proud to tell tales about the legendary treacle mine.

DID YOU KNOW?

The Tovil Treacle Mine is in fact a tall tale that has been circulating for several decades intended to intrigue and entertain local children and visitors to the area. The paper mills around Maidstone were known as 'The Tovil Treacle Mines' by locals. Mill owner Albert E. Reed helped perpetuate the myth by entering a treacle mine themed float into the annual Maidstone carnival.

About the Author

Dean Hollands is a former soldier and retired police officer who was born in Maidstone in 1966 where he lived until he joined the army in 1983. Today much of his time is spent reading, researching and writing for the many walks, talks and tours he undertakes across the UK, Europe and in America.

Among his academic qualifications Dean has an MPhil in Criminology, a MSc in Transformation Management, a BSc (Hons) in Policing and Police Studies and a Post-graduate Certificate in Education.

Dean is a member of the British Legion, Battlefield Trust, Guild of Battlefield Guides and acts as a guide for the Commonwealth War Graves Commission. He is the Chair of Rushmoor Writers and volunteers at the Aldershot Military Museum where he is also the Chair of the Friends of Aldershot Military Museum.

Despite having spent most of his adult life away from Maidstone, Dean has retained a deeply sentimental and nostalgic affiliation with his home town.

Other books by Dean Hollands include *Hampshire's Military Heritage* and *Kent's Military Heritage* (due for publication later in 2019).

Dean and Raff.